Art of the Skull

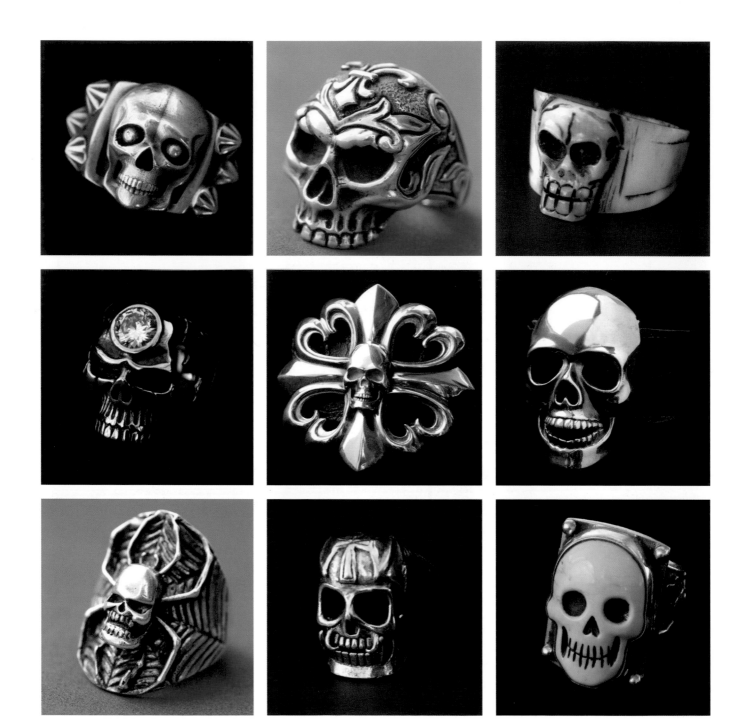

Art of the Skull

MARY EMMERLING
PHOTOGRAPHS BY JIM ARNDT

GIBBS SMITH
TO ENRICH AND INSPIRE HUMANKIND

First Edition
17 16 15 14 13 5 4 3 2 1

Text © 2013 Mary Emmerling
Photographs © 2013 Jim Arndt

Published by
Gibbs Smith
P.O. Box 667
Layton, Utah 84041

1.800.835.4993 orders
www.gibbs-smith.com

Designed by Debbie Berne
Printed and bound in China

Gibbs Smith books are printed on either recycled, 100% post-
consumer waste, FSC-certified papers or on paper produced
from sustainable PEFC-certified forest/controlled wood
source. Learn more at www.pefc.org.

Library of Congress Cataloging-in-Publication Data

Emmerling, Mary Ellisor.
 Art of the skull / Mary Emmerling ; photographs by Jim
Arndt. — First Edition.
 pages cm
 ISBN 978-1-4236-3198-9
1. Skull in art. 2. Skull—Collectibles. I. Arndt, Jim. II. Title.
 N8243.S57E46 2013
 704.9'42—dc23
 2012038788

To my favorite Cowboy and now Skull, Motorcycle
Man, Reg Jackson, what fun we have!

To Jim Arndt for his beautiful photographs and
his hard work, I really thank you.

And always, to my children, Samantha and Jonathan Emmerling,
who are on their way to great careers and love!

—ME

To my skull queen, Nathalie.

—JA

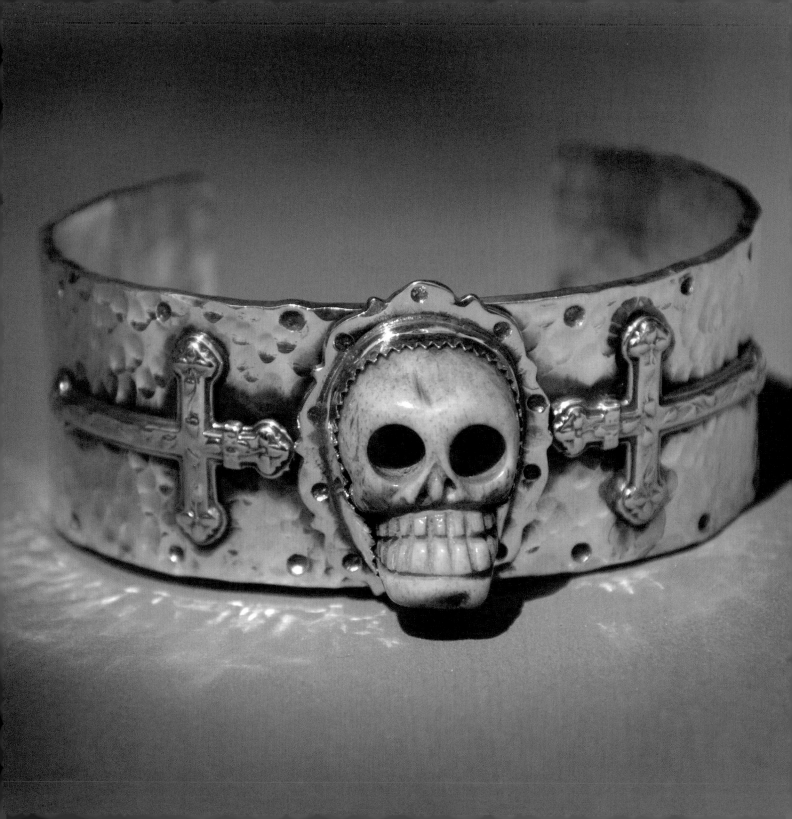

CONTENTS

ACKNOWLEDGMENTS

Thank you, thank you, to all my friends, stores, and galleries who let us photograph their skulls. Whether it was one skull ring or a whole collection of skulls, I appreciate you all.

I went around the country looking in friends' homes at their collections and especially what they were wearing. What fun!

Big thanks and love to: Reg Jackson, Nathalie Kent, Jim Arndt, Robbie Sommer, Bob and Pam Melet, Barbara Trujillo, Jolie Kelter, Michael Malcé, Brian Ramaekers, Lyn Hutchings, Devin Thompson, Carly Homer, Heidi Martincic, Kat Schilke, Gloria List, Julie Feldman, Sharron Saffert, Mona Von Riper, Doug Magnus, Patti Kenner, Julienne Barth, Brett W. Bastien, Rock and Gemz, Santa Fe Flea Market, Walt Borton, Nirve.com, All Saints, Zadig and Voltaire, Cody Foster, Shiprock Trading, Jed Foutz, Arnold Goldstein, Clint Mortenson, Scot Corey, Ann Lawrence, Wendy Lane, Kateryna VanHeisch, Recollections, Susan Franks, Round Top, Hayward Simoneaux, Debbie Berne, and Richard Schmidt. —M.E.

Thanks to all the talented artists for their contributions to this book. And a huge thank-you especially to Nathalie, who inspires me every day. Thanks to: Nathalie Kent, Loree Rodkin, Lee Downey, Doug Magnus, Mona Van Riper, Vram Minassian, Dave Little, John Binsley, Tony Benattar, Bob Kapoun, Pedro Munoz, Clint Mortenson, Les Ochs, Barbara Barratt, Richard Schmidt, Barry Kieselstein, Scott Farrell, John Rippel, Ann Russell, Jeff Deegan, Andrew Valdez, James Stegman, Steve Haske, Corey Miller, Kit Carson, Vera Chaudhry, Jaime Castaneda, Manuelito Cuevas, Michael Gibson, Linda Pearlman, Darryl Willison, and Demian and Alex Danda. —J.A.

INTRODUCTION

S kulls, skulls, skulls—they are everywhere! Of course, I first saw them on Johnny Depp—I love to see what he is wearing on a TV show, movie, walking down the street—*in my dreams!*

I guess I had been collecting for about ten to fifteen years when I first decided I wanted to do a book on skulls. My first skull was a bracelet, then a belt buckle, a ring, and on and on. I only collect "happy skulls"—no depressing ones for me.

When did skulls become art? Apparently, collecting skulls has been going on for quite some time. I have been surprised at how many collectors there are and who does collect skulls. They are quite the conversation piece, just like crosses or turquoise.

Skulls are on tennis shoes, bracelets, scarves, rings, necklaces, pendants, etc. Lately children's clothes have put a broad smile on my face. One of my favorites is a turquoise skull from Doug Magnus. It was a ring, but I asked him to convert it to a pendant. I wear it almost every day!

When I started researching and finding skulls that Jim and I wanted to photograph, I was shocked at how many of my friends had either a whole skull collection or just the "perfect one" that they really liked. Once I was looking for them, every antique show, specialty store, and museum that I walked into had amazing skulls.

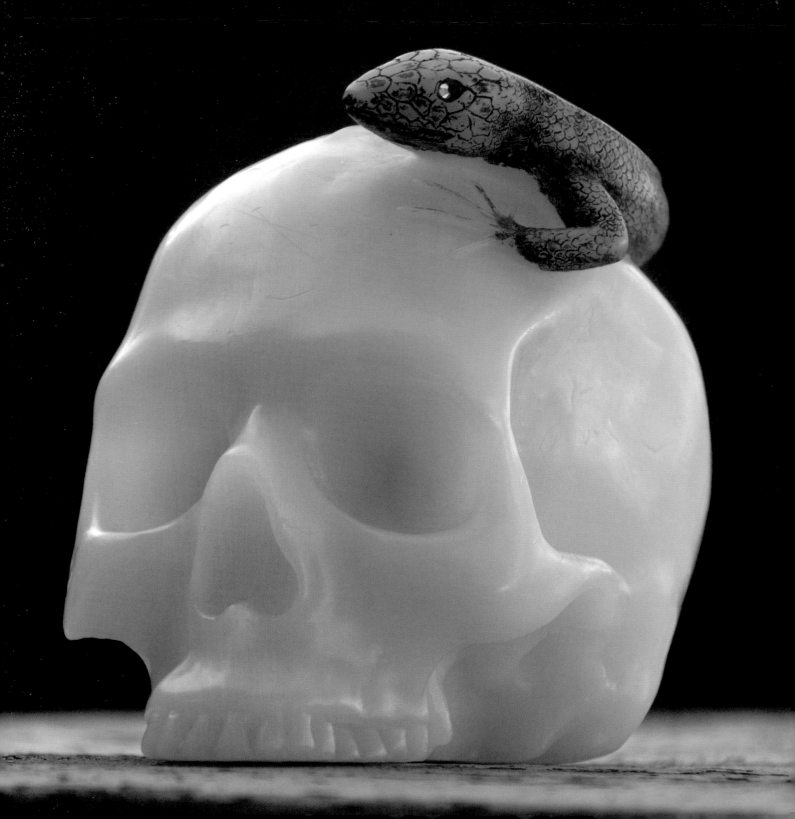

CONTEMPORARY DECORATING

Anyone who knows me knows I love to decorate—with accessories old or new. The decorative skulls we find have also given a sense of humor to my home decor. My heart started beating faster when I found a big skull candle with a lizard on top. And I adore little dishes with skulls on them for setting out candy, as a place for odd smaller things to congregate, or for holding desk and home office necessities such as paper clips and rubber bands.

I even use my jewelry, scarves, purses, rings, bracelets, and necklaces as decorations, hung on peg racks, door handles, heart nails, and contemporary dishes. I use them more when I see them every day.

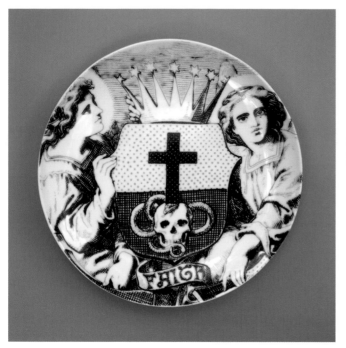 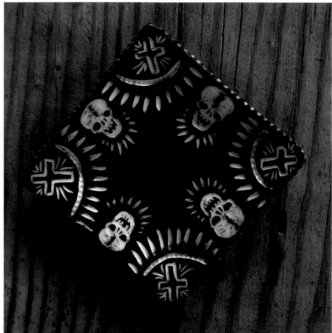

Contemporary and antique skull dishes and
plaques, either as a set or one of a kind, are fun
around the house—on top of a stack of books, on
a side table, or hanging on a hallway wall.

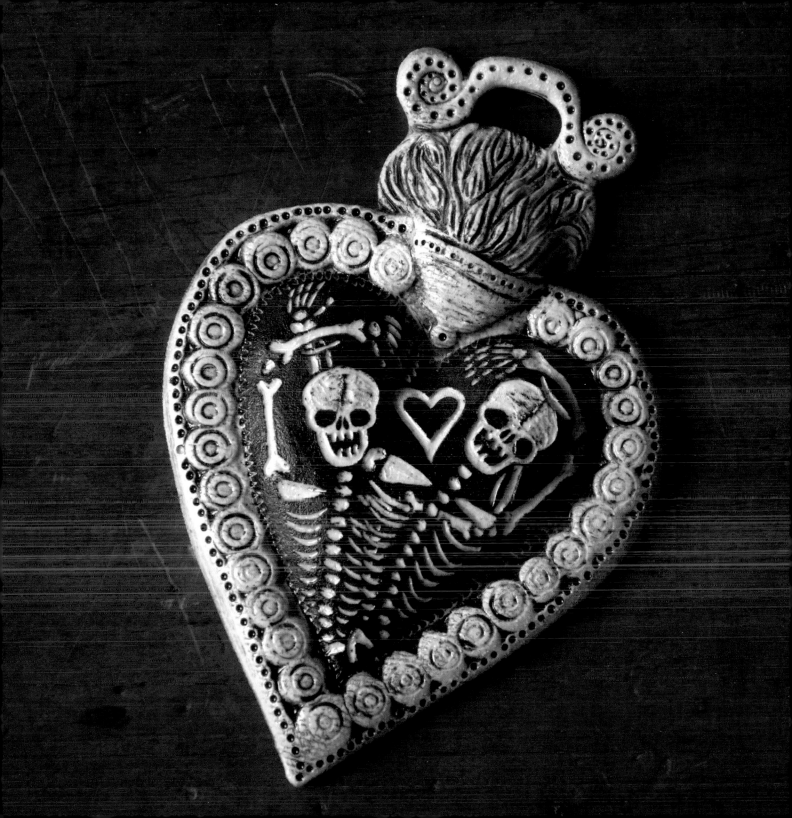

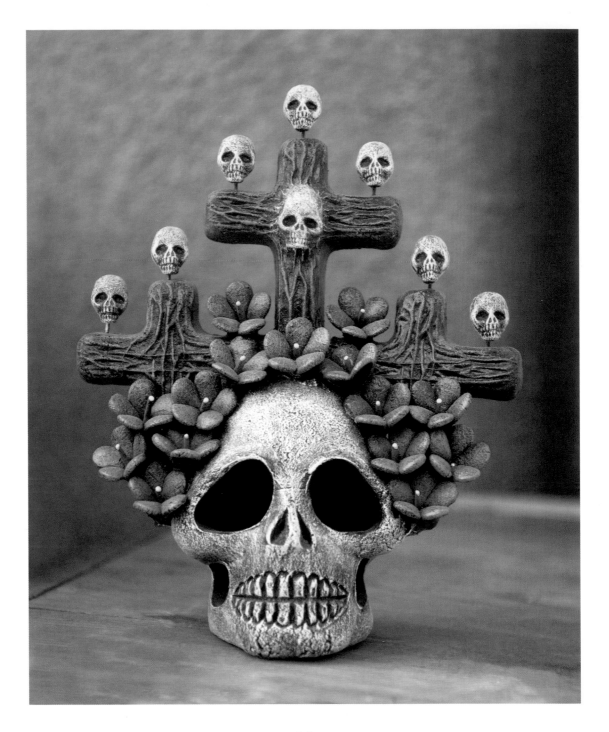

A ceramic sculpture with blue flower head wreath and contemporary rusted iron andirons—very amusing!

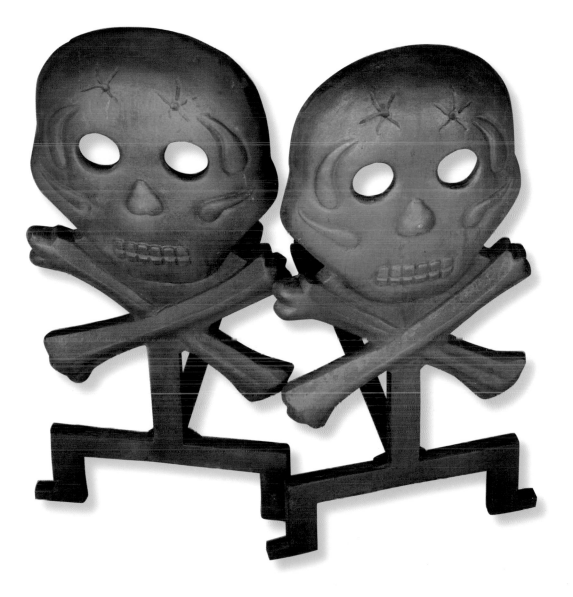

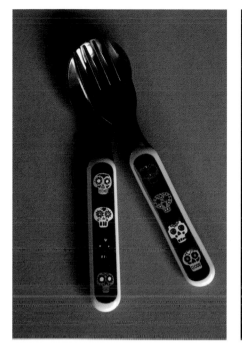

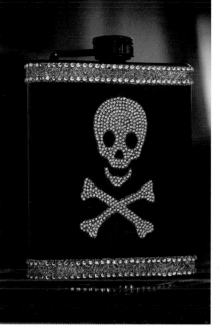

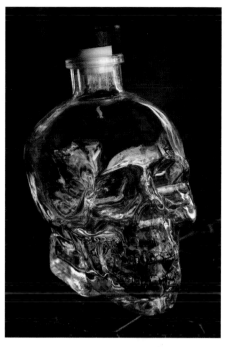

In the kitchen—a spatula, a child's spoon and fork set, a rhinestone-decorated flask, a life-size clear glass bottle, and a rubber ice cube tray.

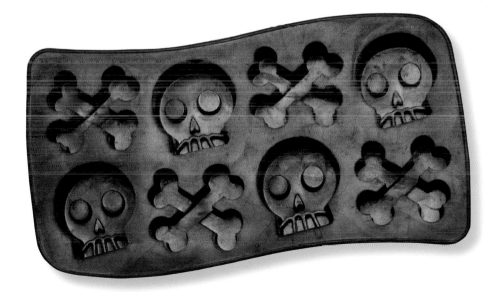

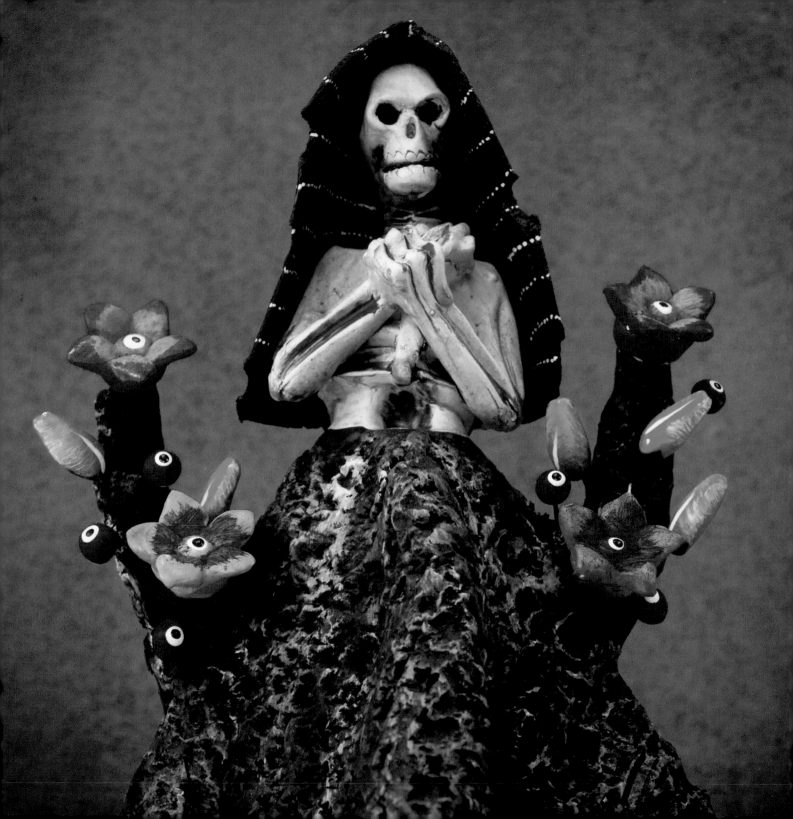

FOLK ART & RELIGION

Old texts point to the skull as the house of the soul. Celtic culture viewed the head, or skull, to be the seat of power. Celts threw skulls into sacred wells as offerings. If you look at the symbolism of water, which carries the meaning of cleansing and purification, hurling a skull into such a place could mean the cleaning of the soul.

Skulls also were placed inside doorways and hallways of ancient ceremonial grounds and sanctuaries, perhaps meant to be a warning.

In religion, death is a resurrection cycle. The skull and crossbones symbolism is also used in imitation rituals as a symbol of rebirth. The gateway to the higher realms is only achievable through a spiritual death and rebirth. A skull did not inspire horror but, on the contrary, promised a new life.

In the Mexican Catholic culture, Day of the Dead (each November 1–2) is set aside to remember deceased relatives and saints.

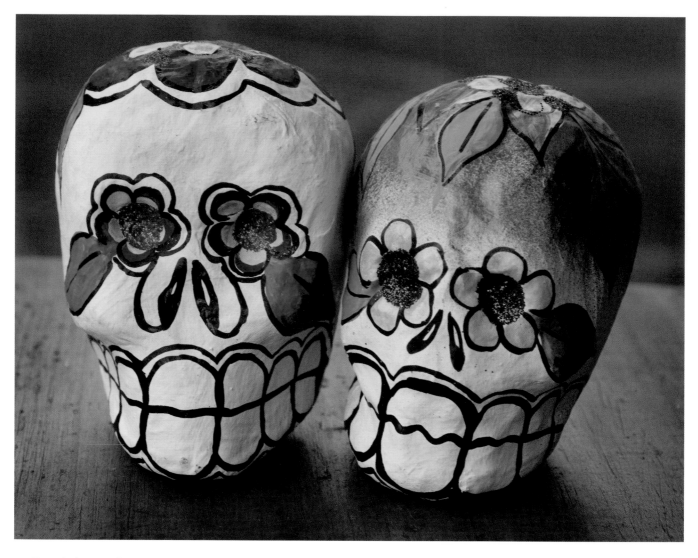

People love collecting papier-mâché skulls painted
in a variety of colors and patterns. Cutout drink
coasters brighten up a home for parties and
holidays, while painted tin ornaments decorate the
Christmas tree or hang on a wall.

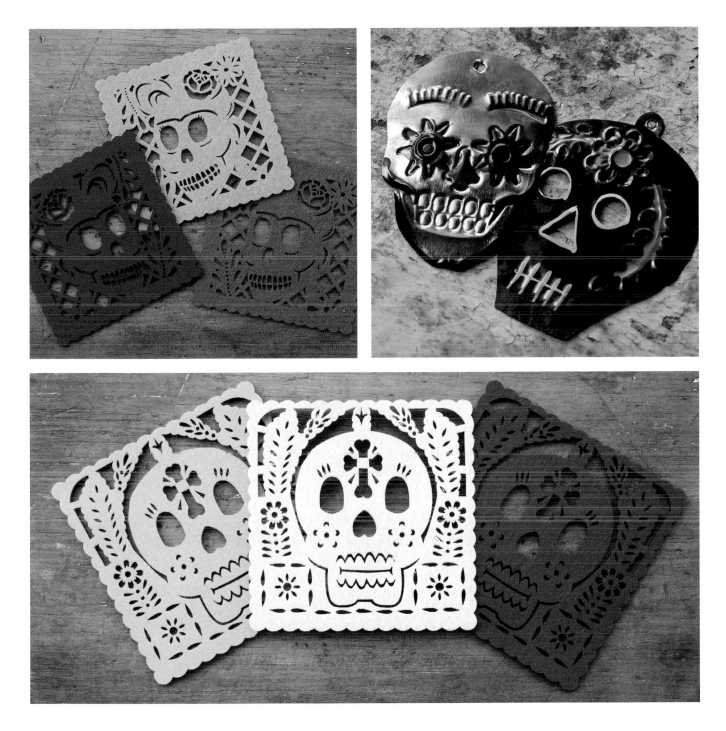

Catrina—an upper-class woman depicted as a humorous skeleton—originated from artist José Guadalupe Posada as a Day of the Dead symbol. She is interpreted by many artists and remains one of the most popular and recognizable Day of the Dead figures. The buckle here is certainly eye-catching.

Facing: The ultimate architecture is the human skeleton; this cowboy is a perfectly carved example.

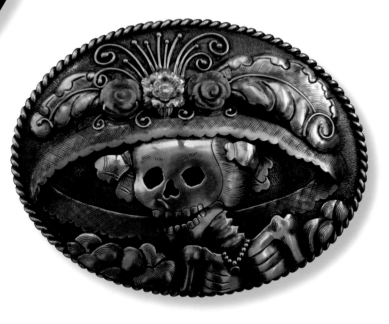

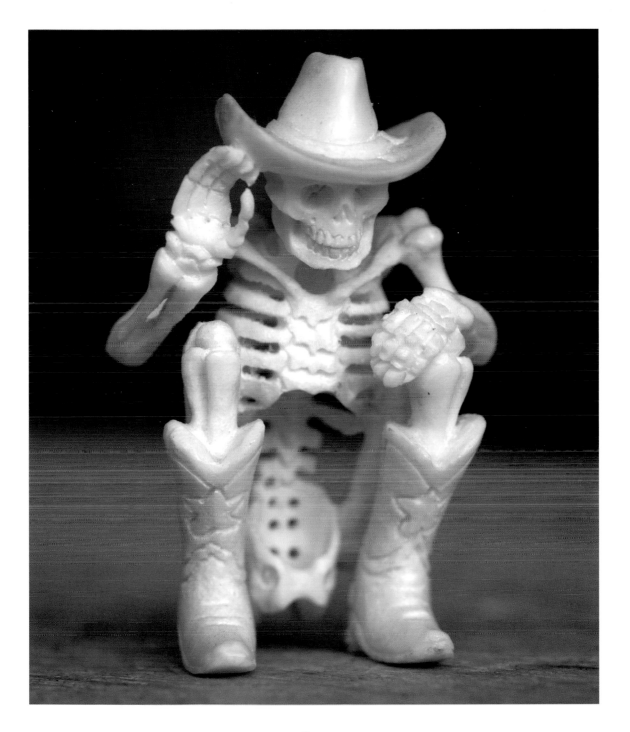

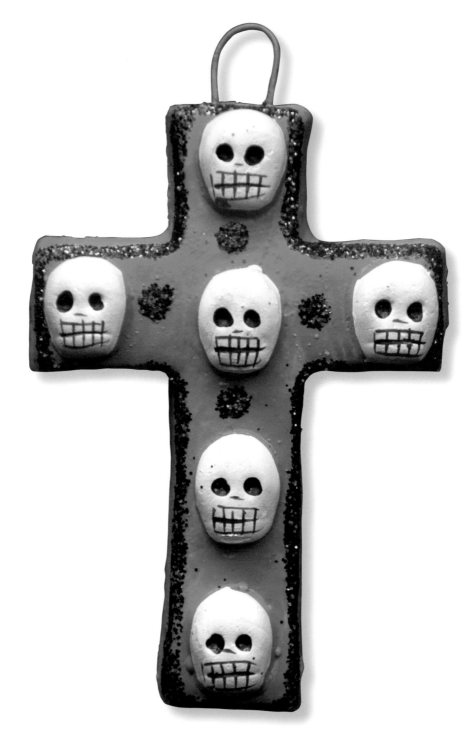

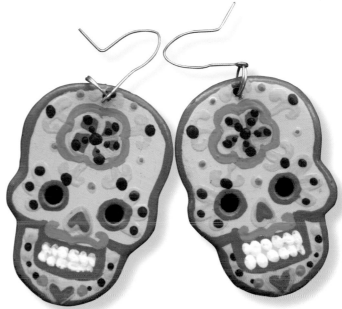

Whimsical confetti for a Halloween party, painted tin earrings from Mexico (a special present), and a painted tin candlestick.

Facing: A ceramic folk art cross, Day of the Dead style.

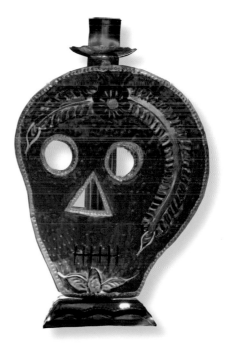

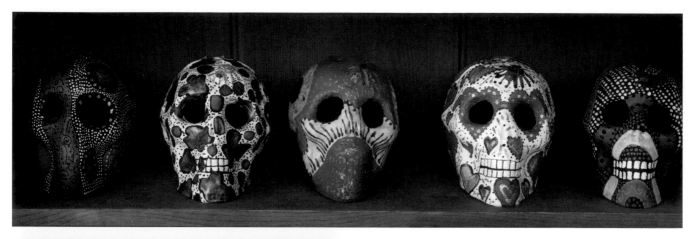

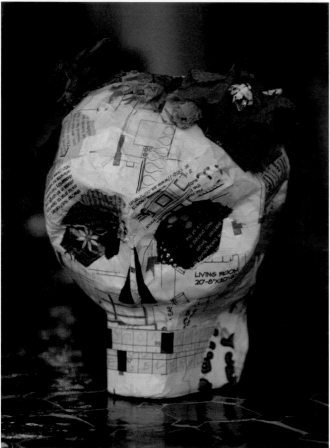

Such creativity in papier-mâché masks for parties, decorating, or party favors. Fun hand towels liven up a room.

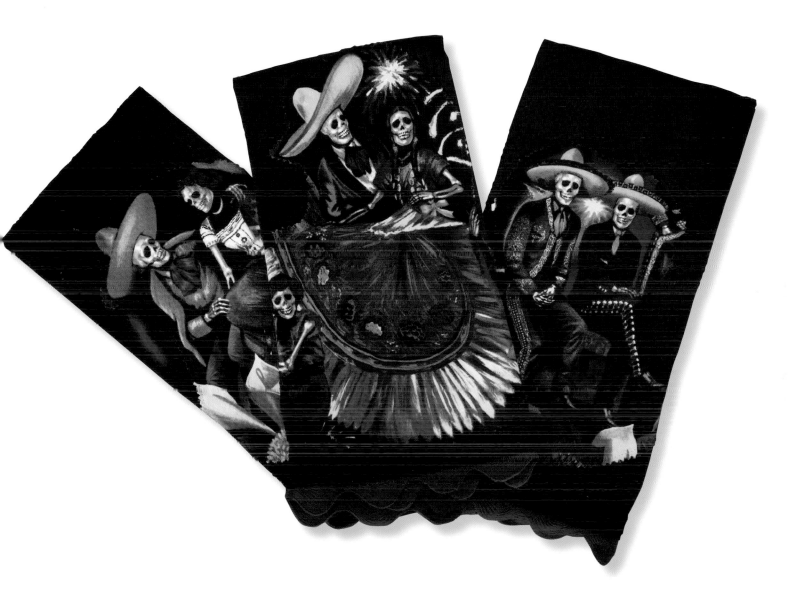

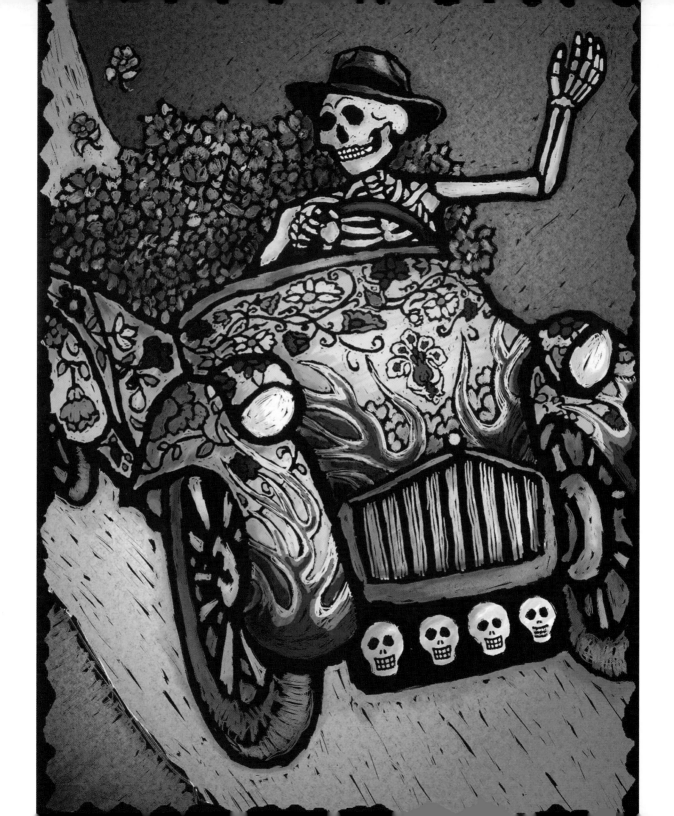

Day of the Dead artwork takes many forms; this
guy is out for a cruise (facing). The paper garland
is like a prayer flag but with skulls. The Catrina Day
of the Dead motif decorates a box of matches.

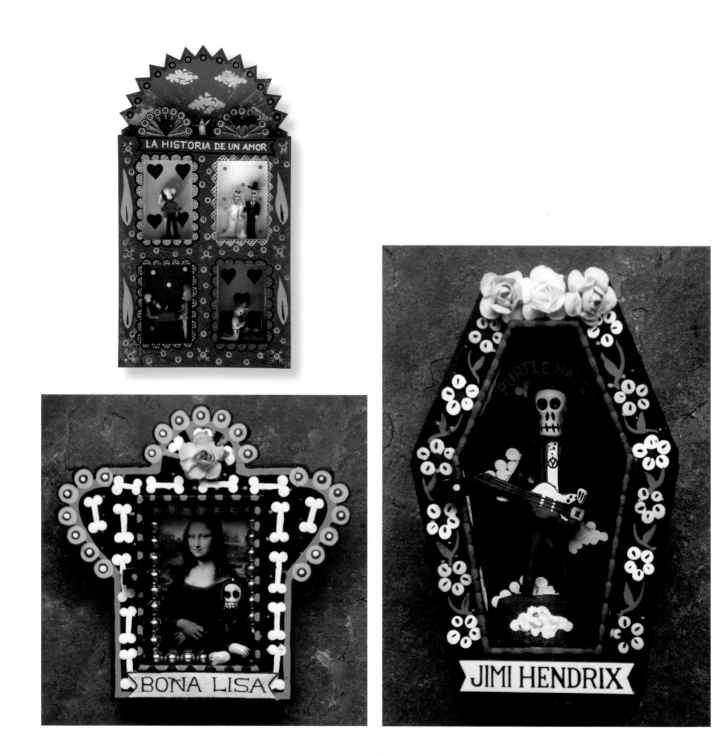

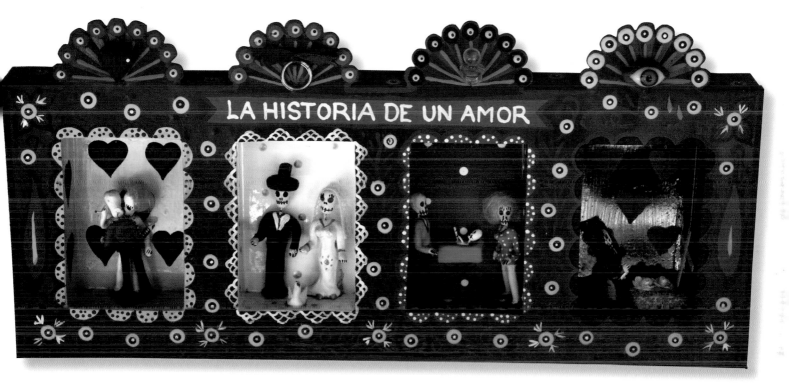

In shadow box style, folk artists have captured
the "history of love" (above and facing top) and
imbued their art with humor.

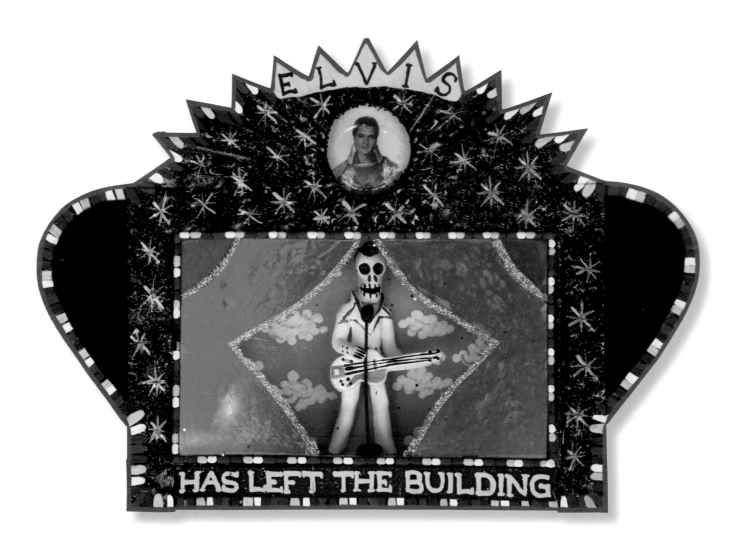

ELVIS

HAS LEFT THE BUILDING

Painted Mexican tin folk art celebrates everybody's
favorite rock icons.

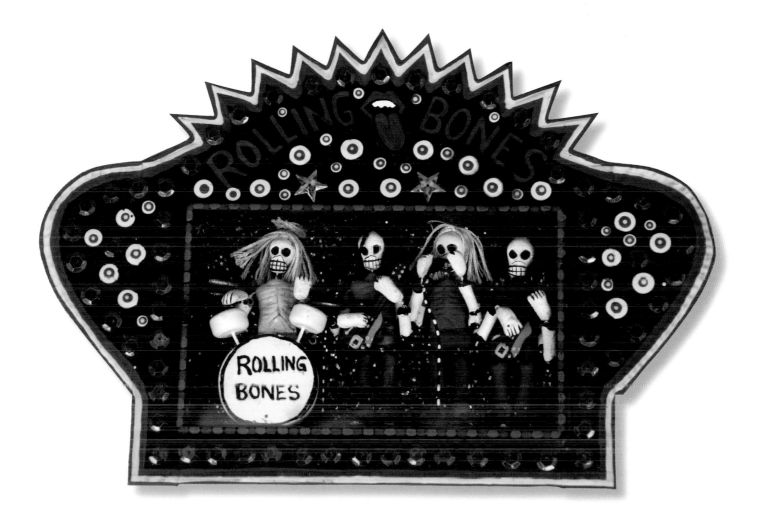

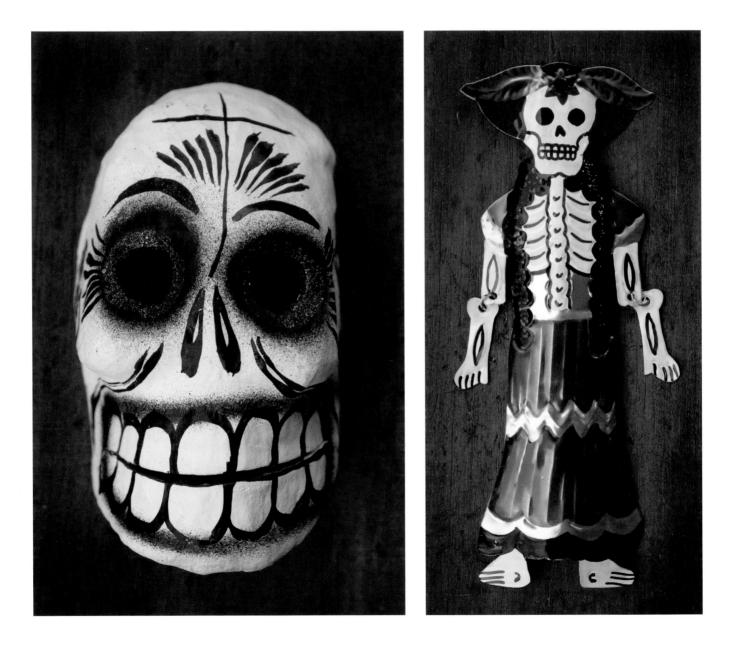

Papier-mâché folk art for the Day of the Dead are on the right and far left. The middle skeleton is tin.

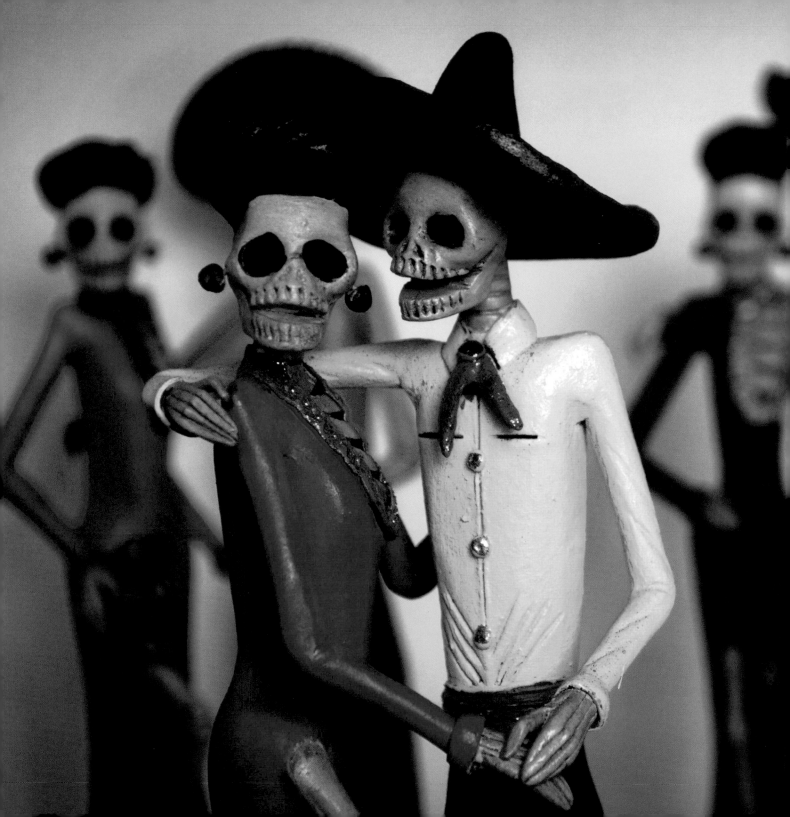

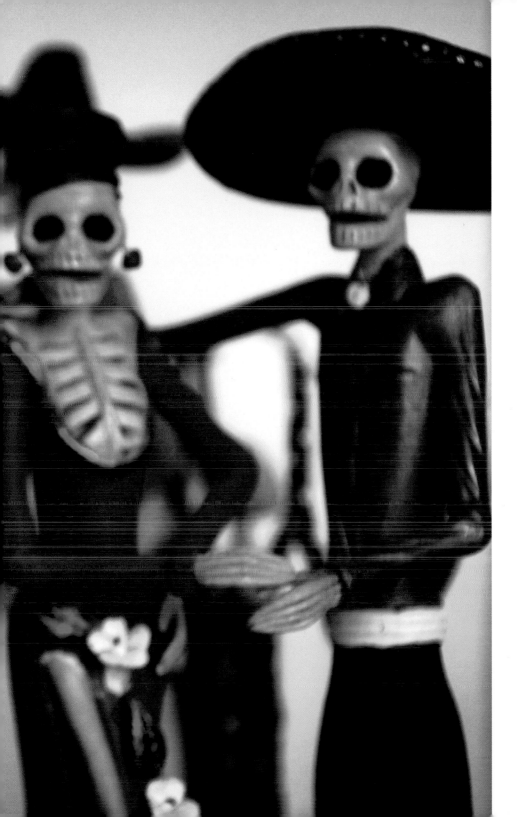

Day of the Dead Mexican clay figurines dancing with their partners.

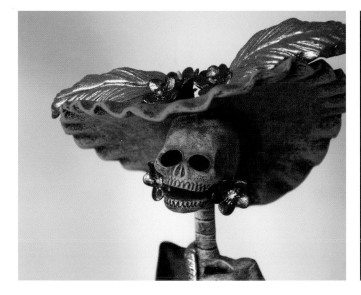

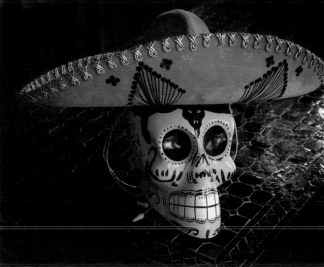

Most Mexican folk art for Day of the Dead is painted in lively colors and with broad smiles. There is nothing gruesome about these celebration skulls.

Left: a metal belt buckle.

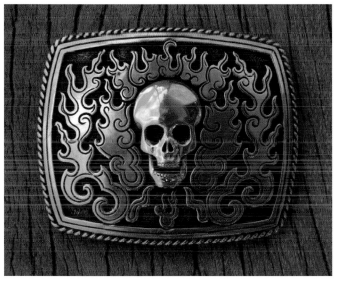

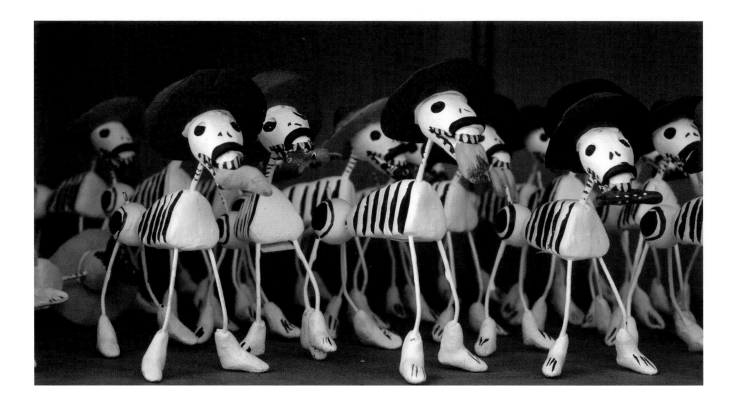

Day of the Dead figurines come in all configurations,
including athletes; in this instance, whimsical teams
of cats and dogs, a football player, and a bicyclist.

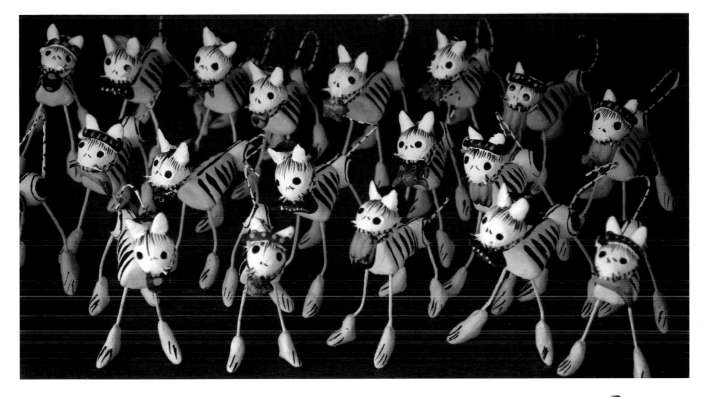

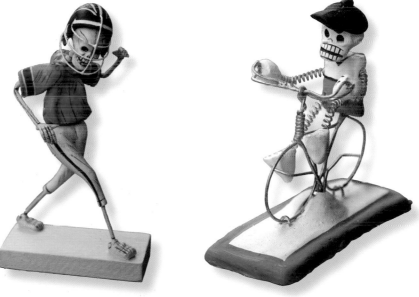

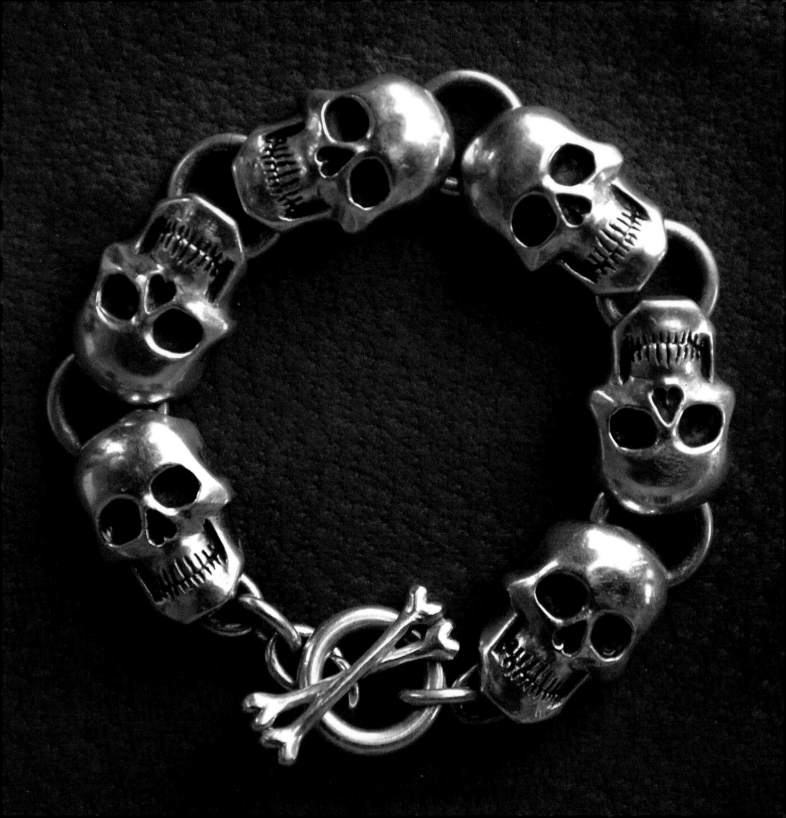

JEWELRY

~

Anyone who knows me knows that I love jewelry more than anything one wears. Jewelry makes such a big statement about a person's personality or mood. When you wear a skull ring, a skull pendant, bracelet, belt buckle, or even skulls on a pair of cowboy boots, it is a guaranteed conversation starter.

I had thought that leopard print was my favorite thing to wear, but I am quickly realizing that skulls have become my favorite. Especially when paired with the color turquoise!

Take a minute to look through the jewelry cases at your favorite shops. You'll be surprised by the sheer diversity of materials used to create our favorite baubles—diamonds, gold, silver, crystal, plastic, resin, glass, you name it! Remember, skulls are engaging symbols of rebirth.

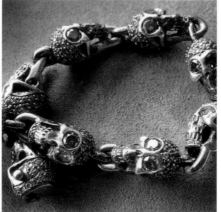
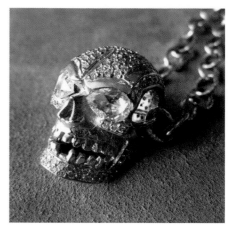

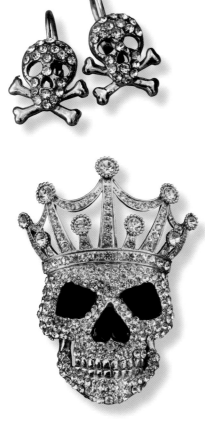

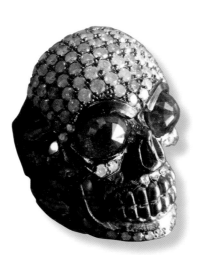

Turquoise and bling—my two favorite colors in jewelry! To the left, center is a fabulous pave diamond-encrusted ring—an extraordinary skull ring.

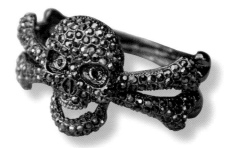

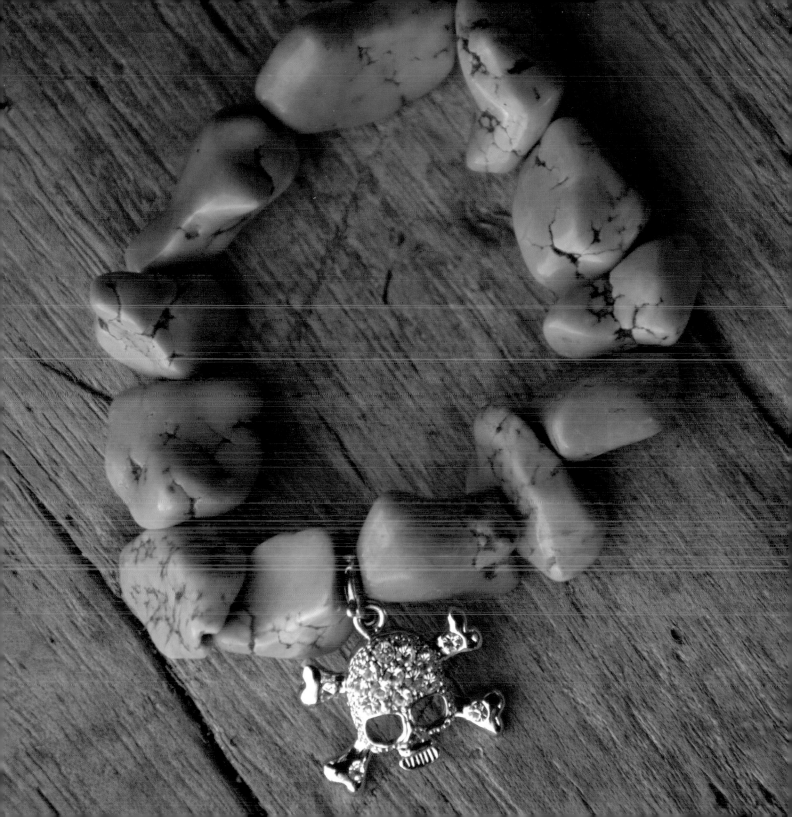

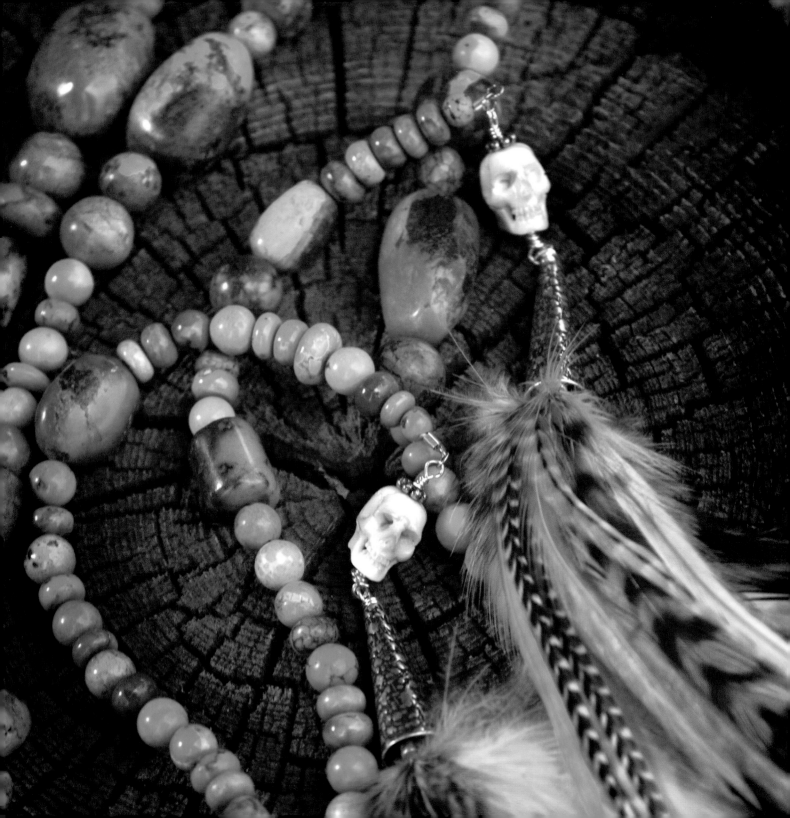

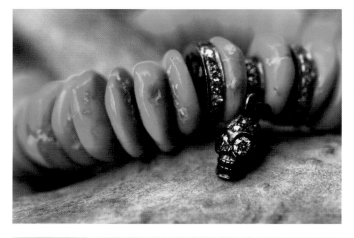

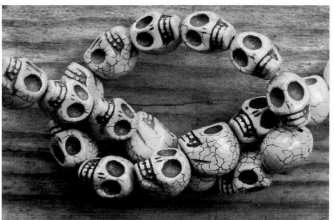

Facing: Turquoise beads with dangling skulls and feathers is a wrap necklace.

This page. A black rhodium mini skull with pave diamonds on a natural turquoise bracelet; turquoise skulls; ebony and ivory; a bracelet chain of carved ivory skulls.

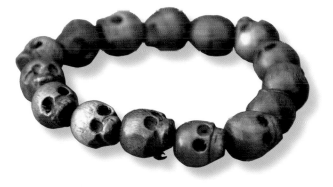

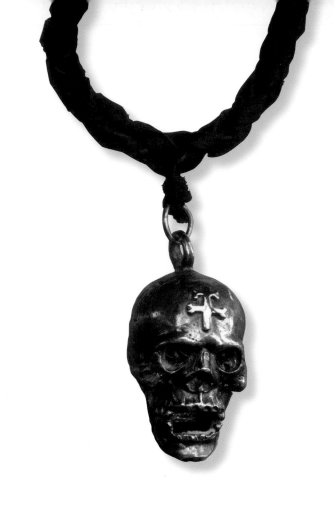

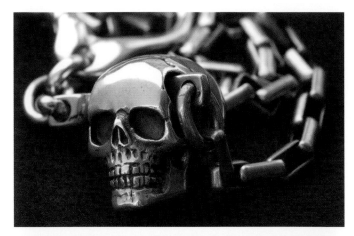

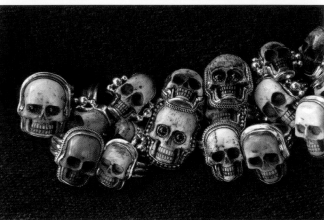

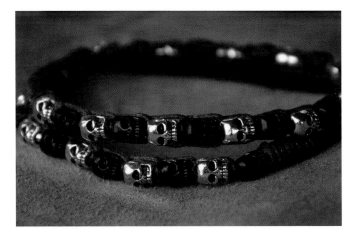

Skulls all shiny, bright, and beguiling.

Top left: Wood beads with silver skull embellished with a gold cross.

Top right: Skull wallet chain.

Above: Collection of bone silver-mounted rings.

Left: Leather braided wrap bracelet with alternating silver and black skulls.

Facing: Gold and sterling engraved buckle.

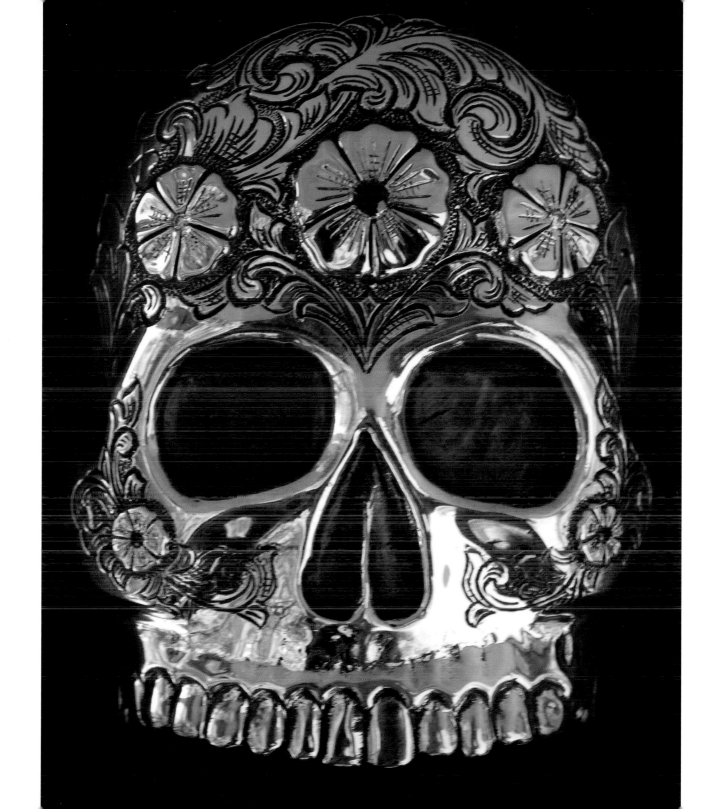

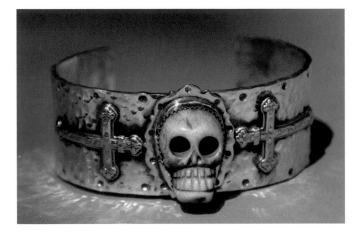

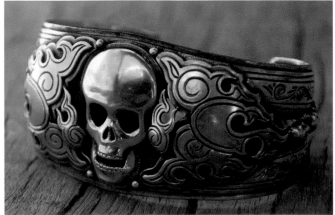

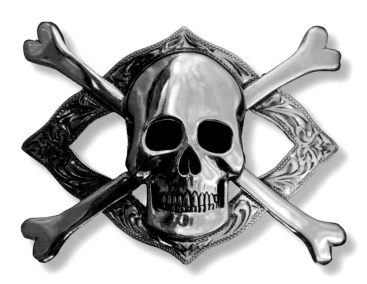

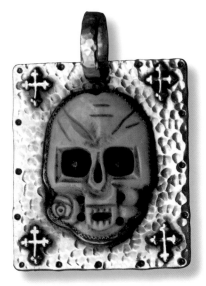

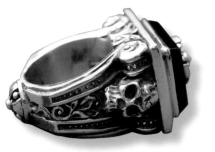

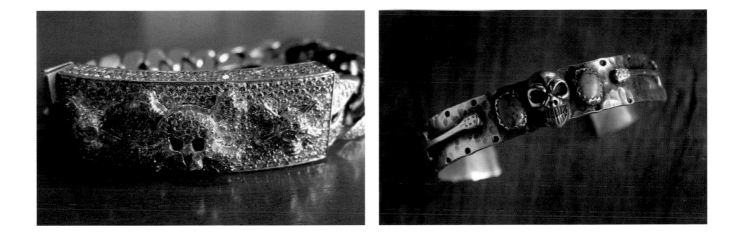

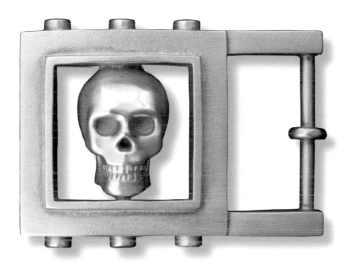

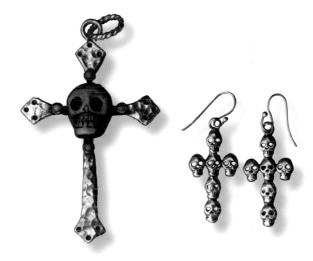

Texture has been masterfully crafted into these
gorgeous pieces of jewelry art.

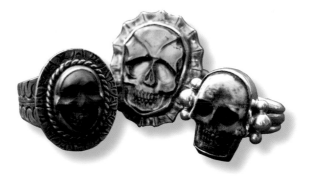

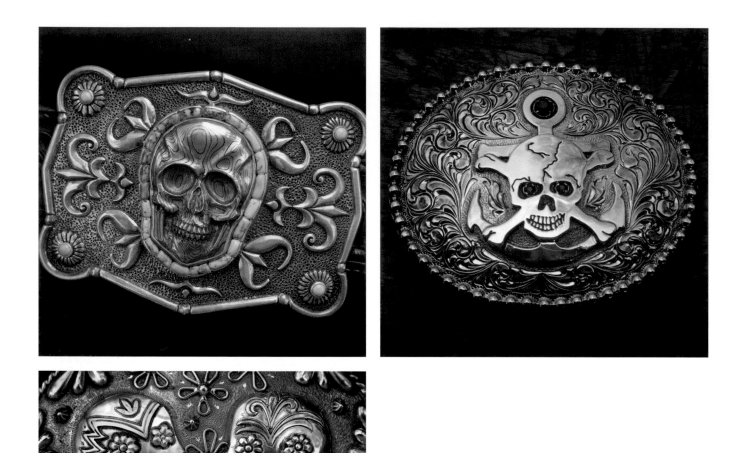

Buckles are signature statement pieces—each skull having a unique personality and in a variety of shapes.

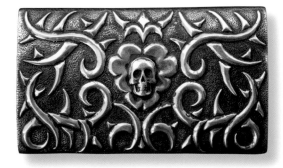

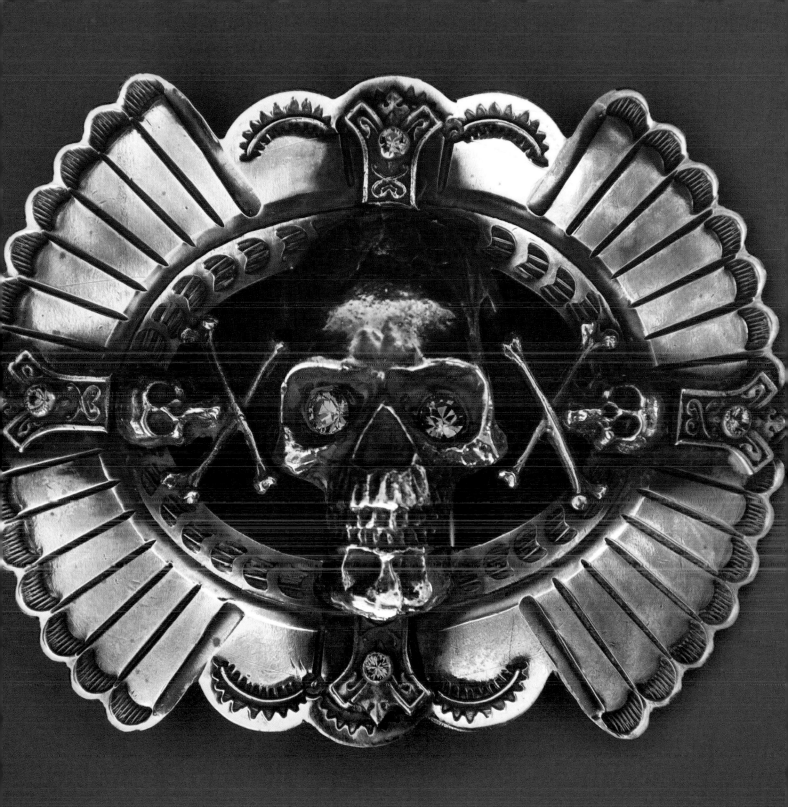

I found all these charms while researching for this book. This collection will bring up fond memories of the experience! A skull with turquoise, an elk's tooth mounted in silver, a tooth with engraved silver, and a New Mexico silver zia.

Facing: A hatband pin; a variety of bone or antler pendants are necklace-ready; the one at left is an incense holder.

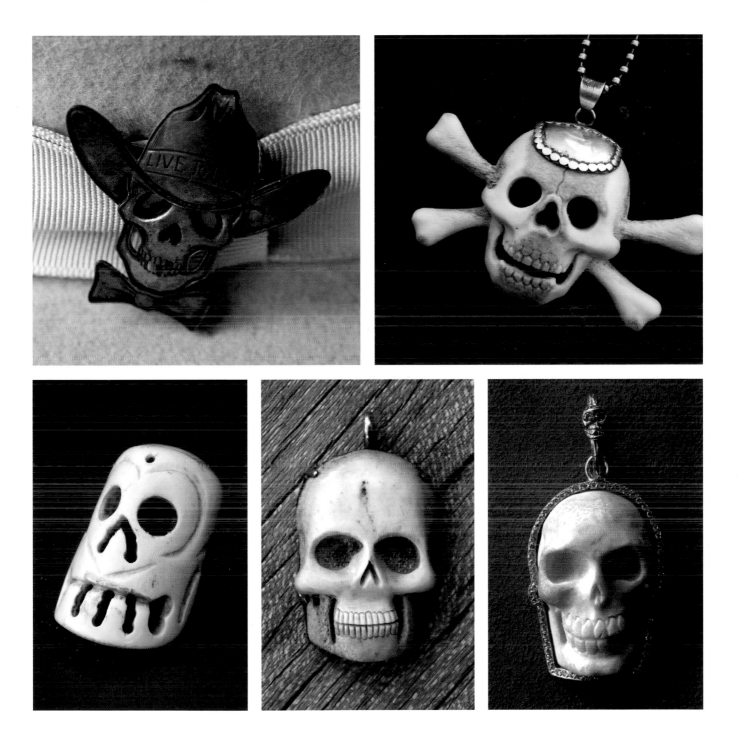

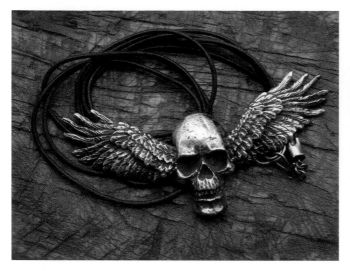

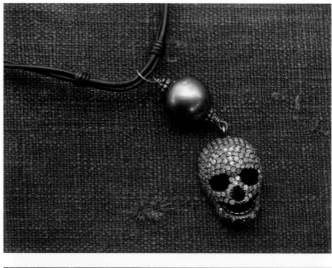

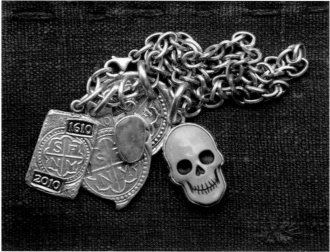

A winged skull on a triple leather necklace; a black diamond skull with black pearl; and a smiling turquoise beauty.

Facing: Beads in natural bone with hanging bone skulls and wool string.

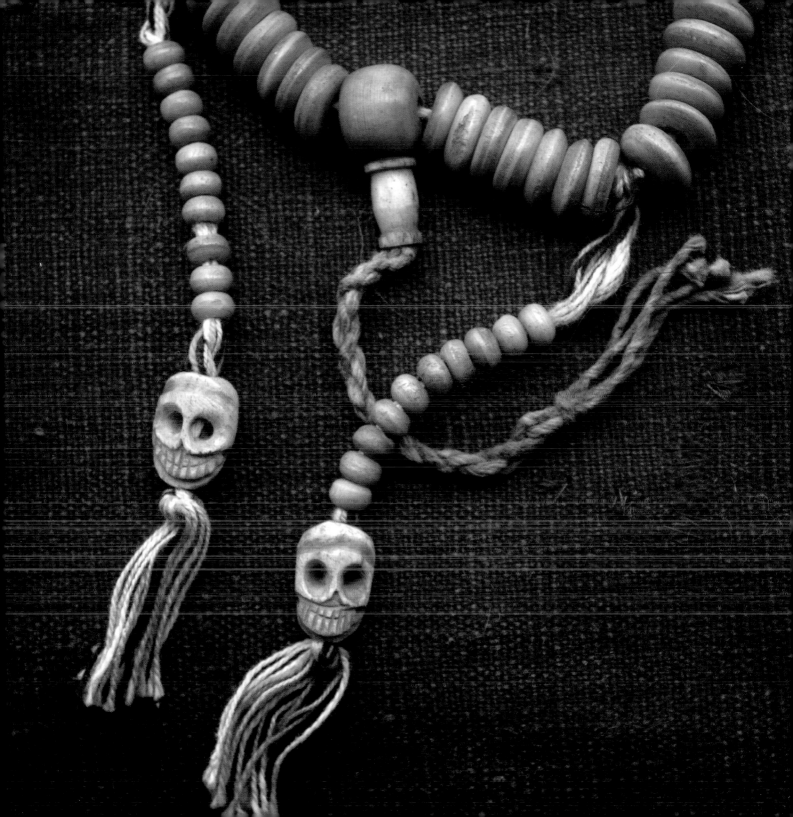

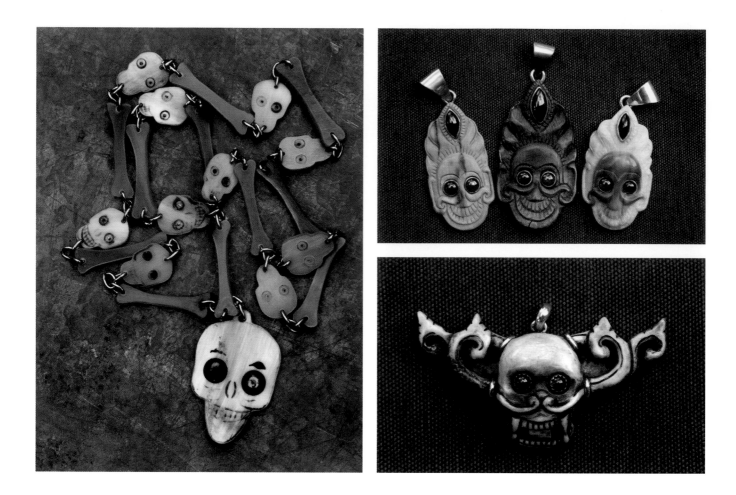

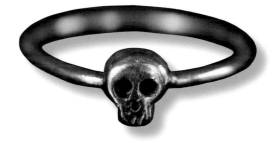

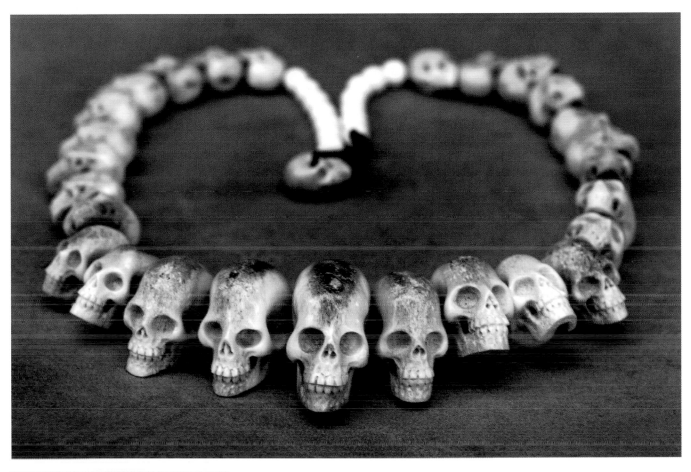

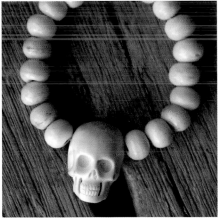

Facing: Skull and bones necklace; bone skull pendants with purple stone eyes; skull with fancy silver ivory trim pendant; tiny gold skull on a silver ring.

This page: Statement necklace of natural bone beads in graduating sizes; ivory bone beads and skull.

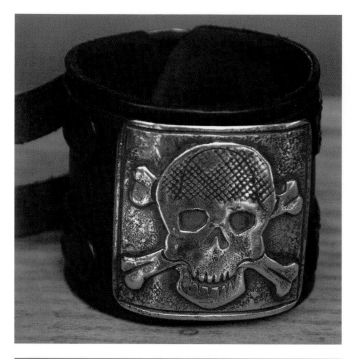

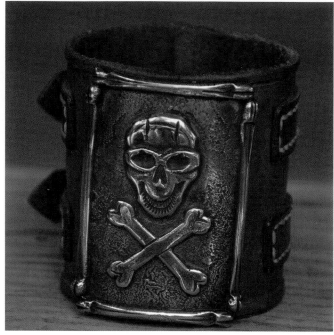

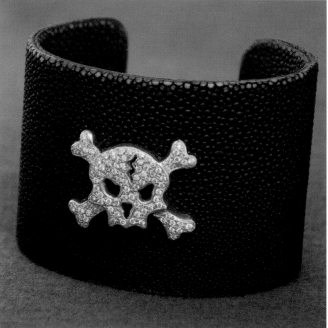

Ketoh/bowguard bracelets with wide bands and straps frame the sterling silver skull art.

Left: A stingray cuff bracelet enhanced with a pave diamond skull on 18k white gold.

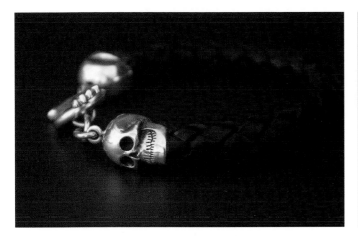

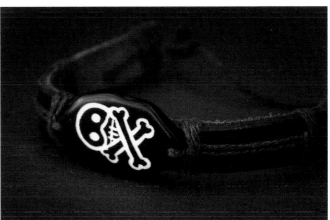

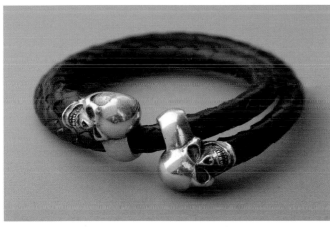

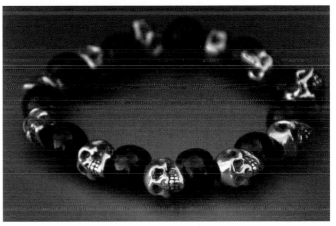

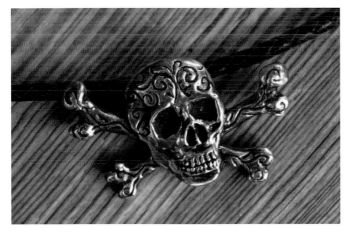

Top: Braided leather bracelet with skull end and bone closer; leather bracelet with plastic skull and crossbones.

Center: Braided leather bracelet with adjustable sterling silver endings; black wood beads with sterling skulls on an elastic band.

Bottom: Sterling silver pendant skull and crossbones.

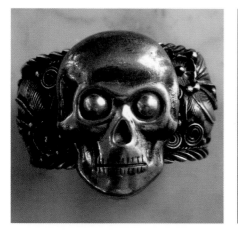

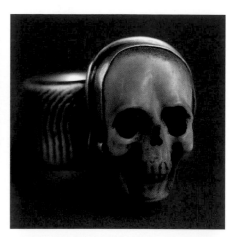

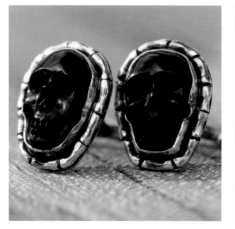
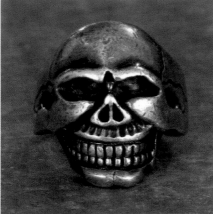
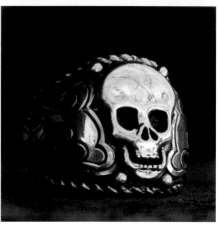

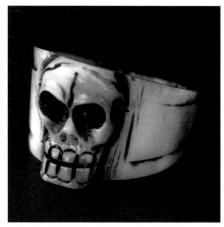
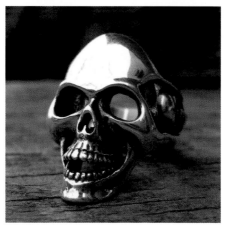

Killer rings are interrupted by a pair of cuff links (center left).

Facing: This skull and bones chain holds a biker's wallet and attaches to the rider's belt.

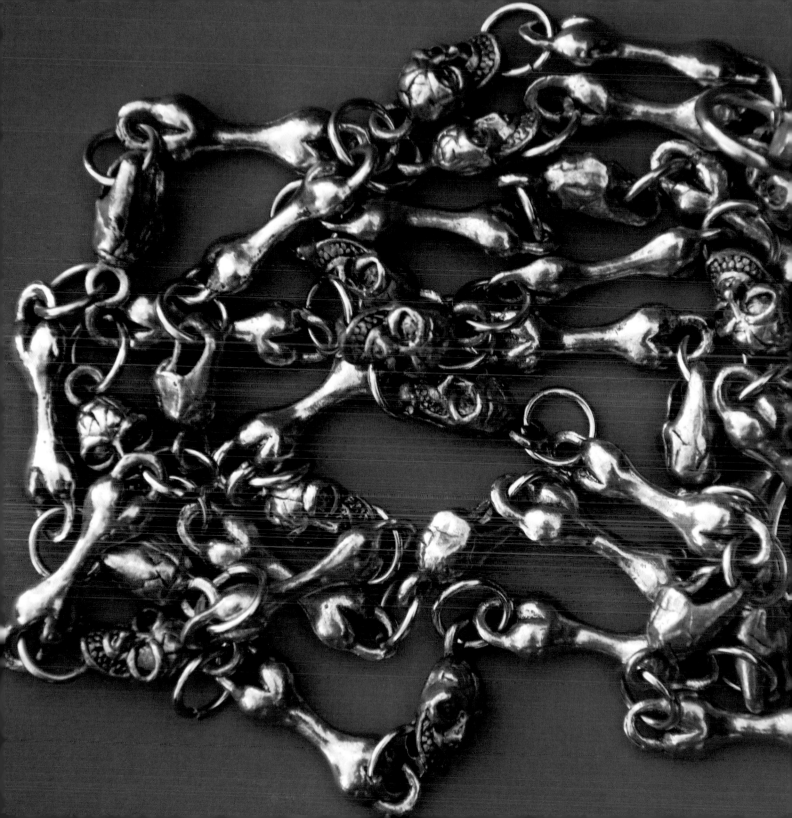

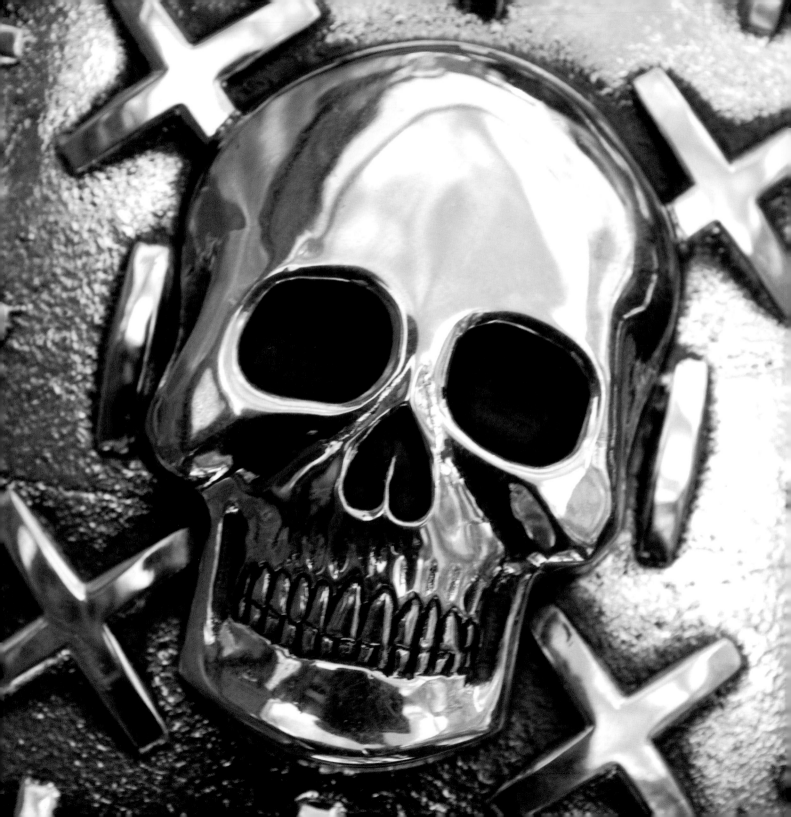

These designs are truly outstanding!

Facing: Sterling skull on a belt buckle.

This page: Small sterling silver belt buckle; winged skull I.D. bracelet.

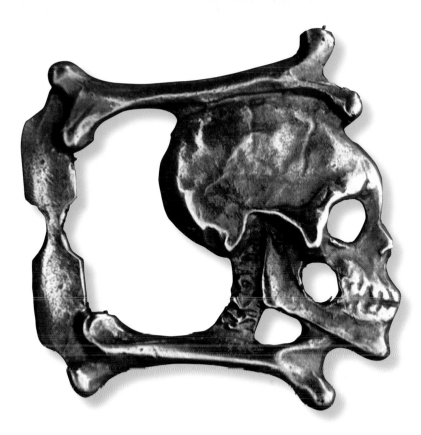

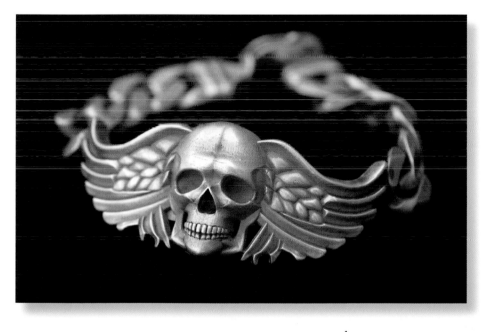

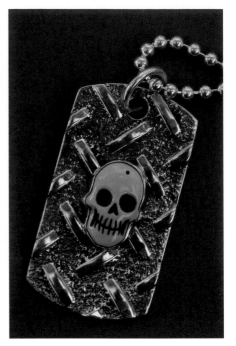

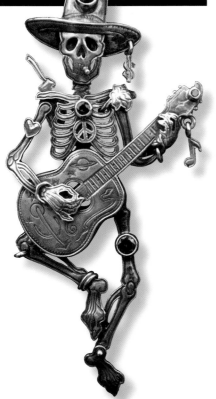

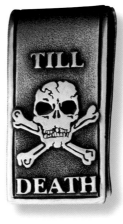

TILL

DEATH

Toothy grins on pendants and pins. Below: a sterling silver money clip.

Facing, clockwise from top left: Tiered skull necklace; Mexican skull pin; unique scarecrow skeleton pendant; skull with wings ID bracelet; fabulous skull Indian sterling silver ring.

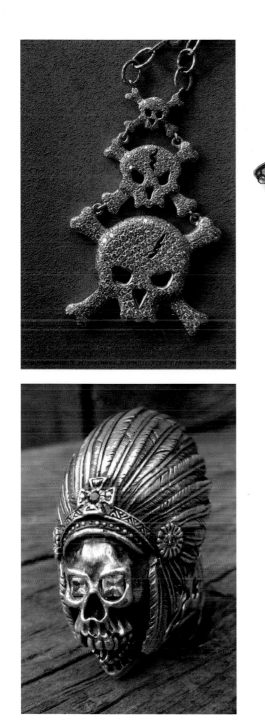

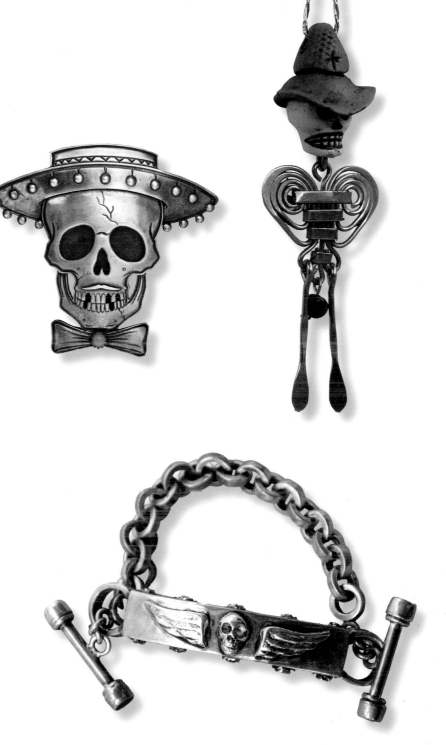

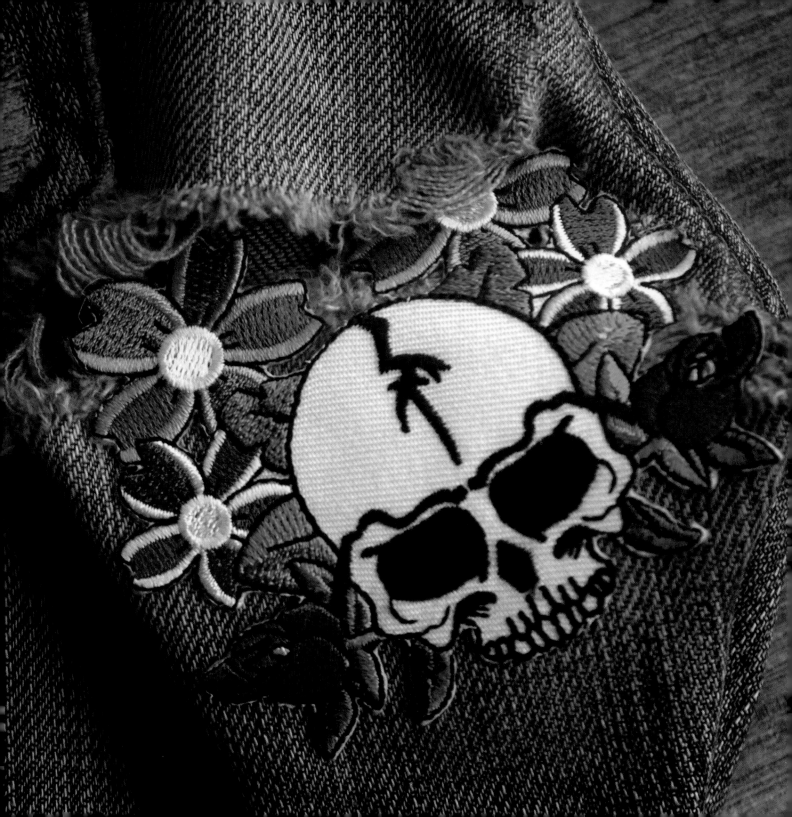

CLOTHING & ACCESSORIES

⌘

Who doesn't love to buy clothing and put together pieces that make unique outfits? When I find a piece of clothing with a skull on it—a T-shirt, sweater, baseball cap, denim jacket, socks, scarf, boots, anything—I have to have it! Wearing skulls is such fun. Some are painted on, some are applied to fabric as beads, and some are sketched out in sewn-on rhinestones. I get wonderful compliments on each and every one.

Lately, children's clothes have put a broad smile on my face. Recently, in an upscale kids shop in Newport, I was wishing I could shrink to the available sizes. There were hoody tees, tights, knit caps, even puffy vests, and big smiles on the kids' faces looking at the skulls, saying, "Mommy, I want that!"

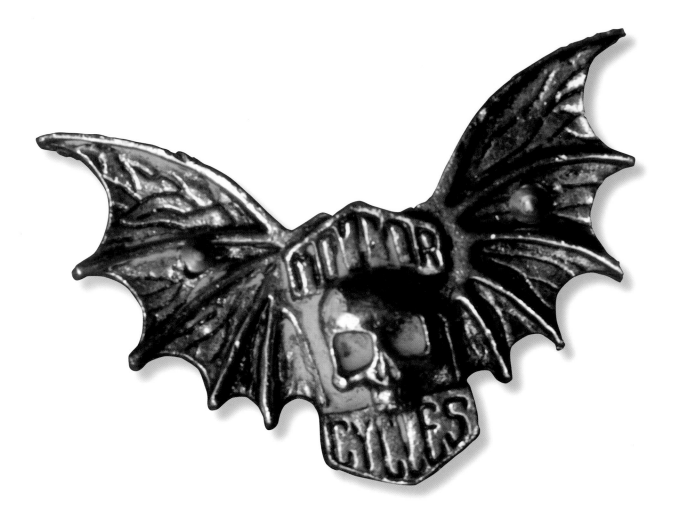

Previous overleaf: A jeans patch.

Above: A motorcycle pin.

Facing: I bought this jacket at the beach and didn't even notice the skull button until months later.

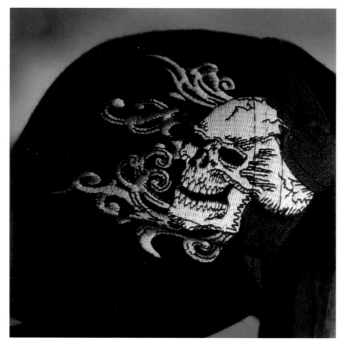

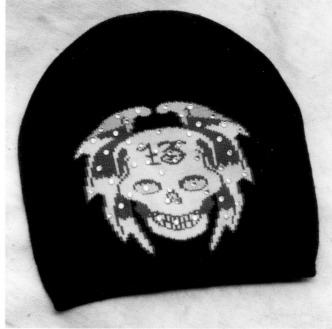

A baseball cap; a Ralph Lauren candle; a knit hat; a Rugby by Ralph Lauren baseball cap.

Facing: A cowboy hat.

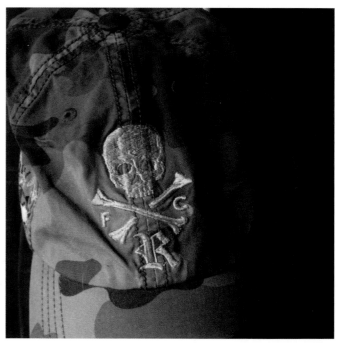

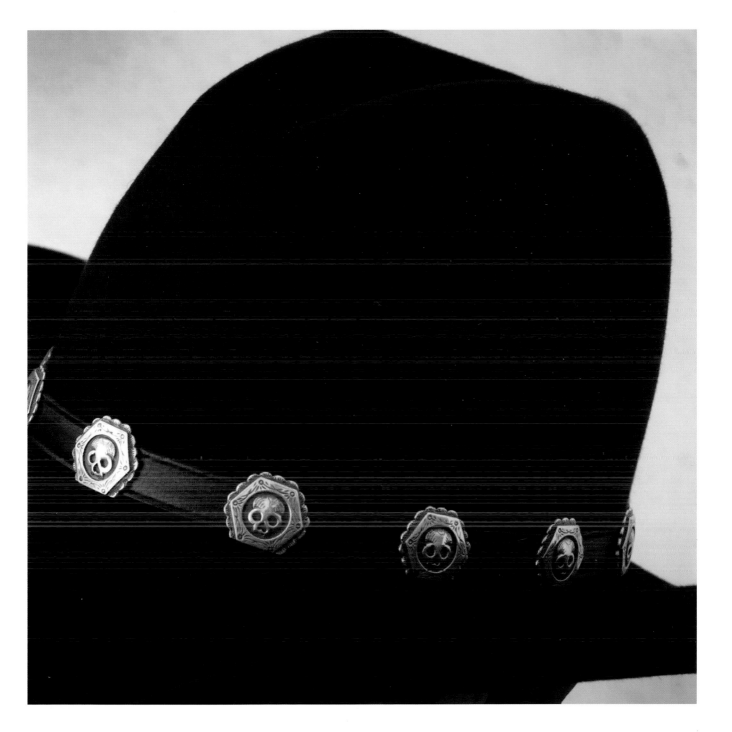

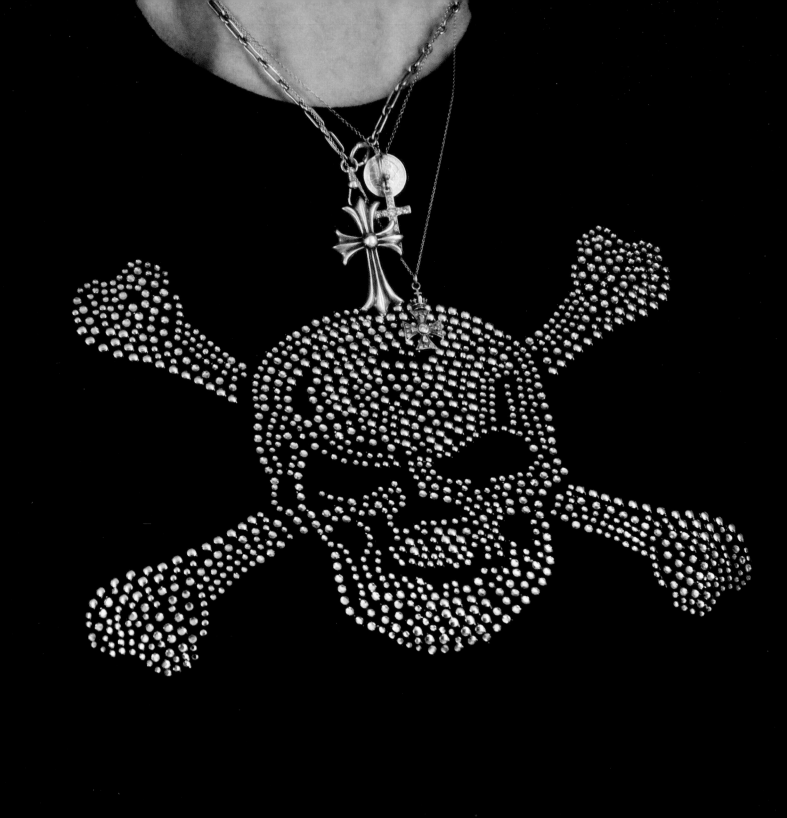

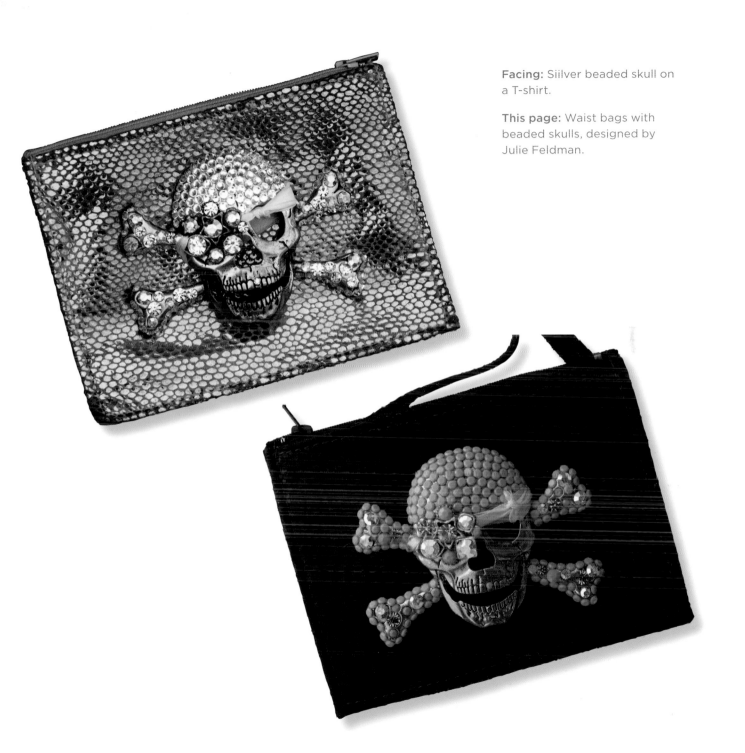

Facing: Siilver beaded skull on a T-shirt.

This page: Waist bags with beaded skulls, designed by Julie Feldman.

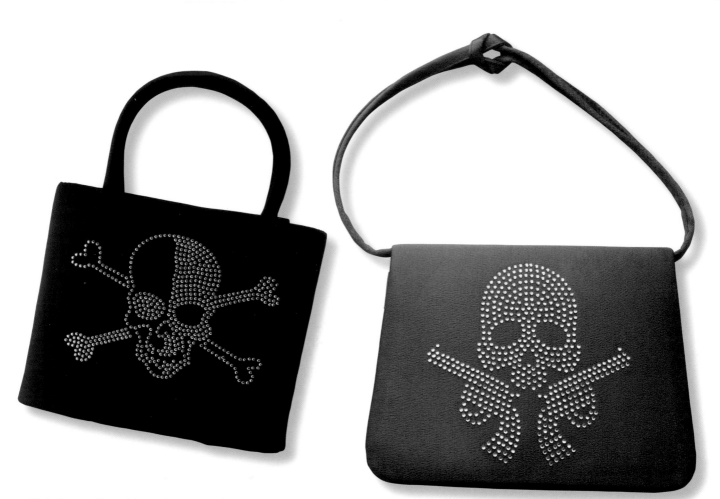

Pink Two Julie Feldman bags—skull and crossbones on the left, skull and guns n the right.

Facing: A round silver beaded evening bag.

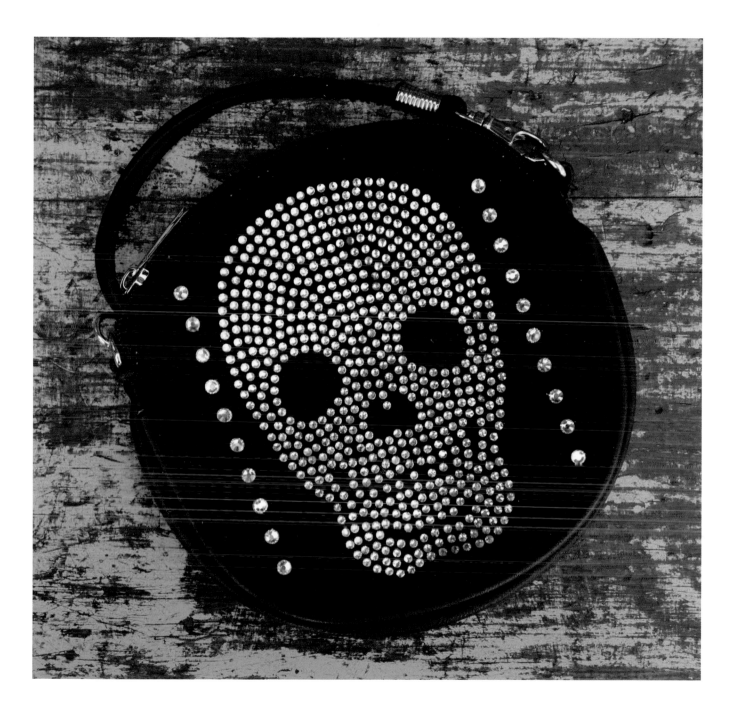

Facing: Fabric, scarf, and suspender details.

This page: Textile details and embroidered buttons.

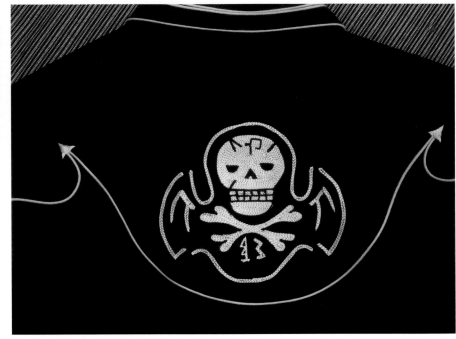

Shirt art: Above right, a simple but stylized embroidered skull on a Western shirt.

Facing: A machine-stitched skull on red fabric carries several types of symbolism.

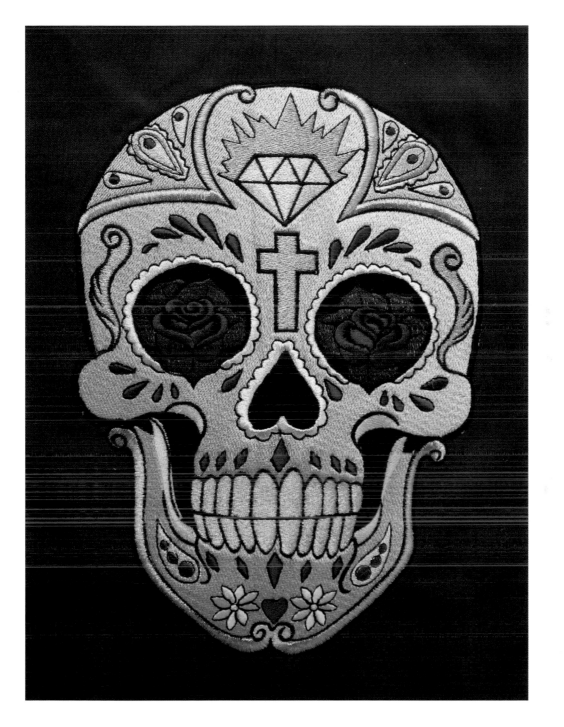

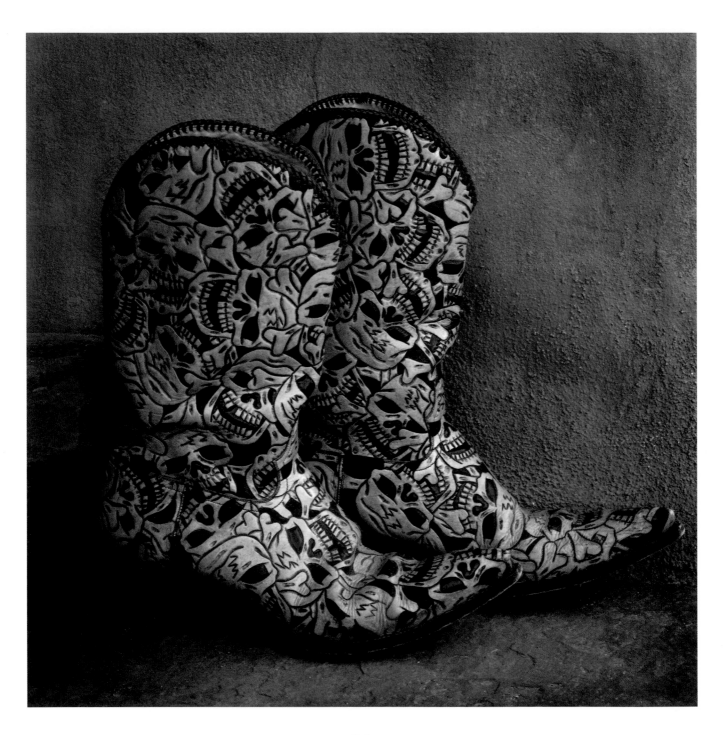

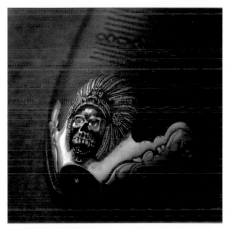

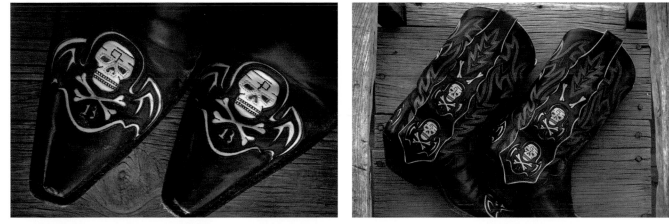

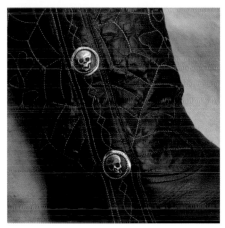

Skull motifs in stitching, tooling, carving, and silver decorate custom cowboy boots.

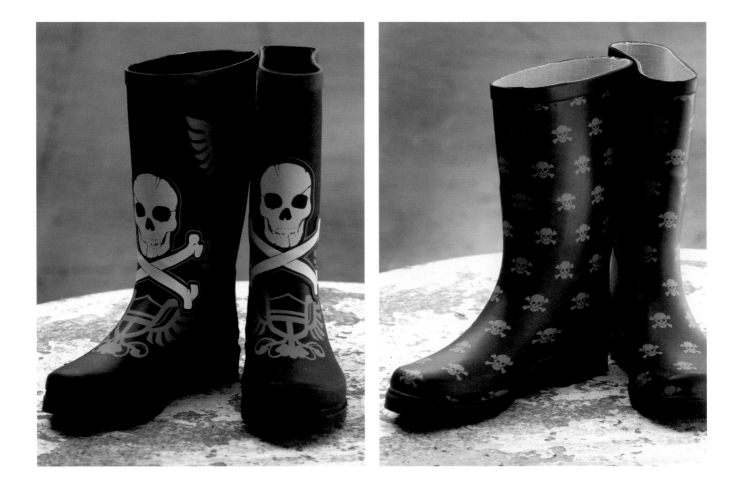

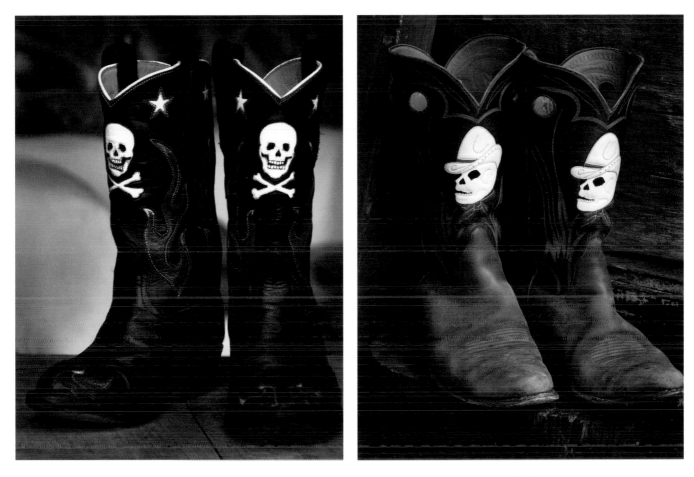

In rubber or leather, skull boots are a knockout!

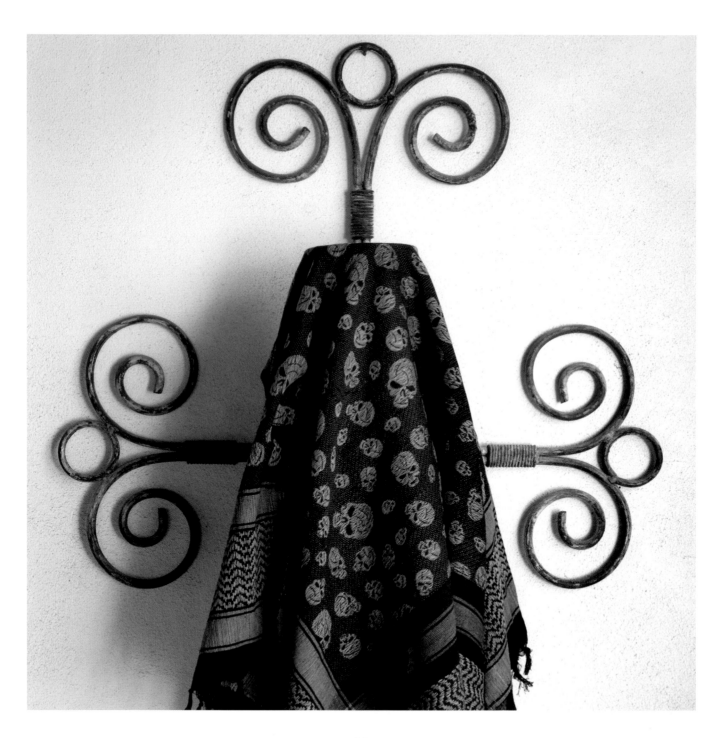

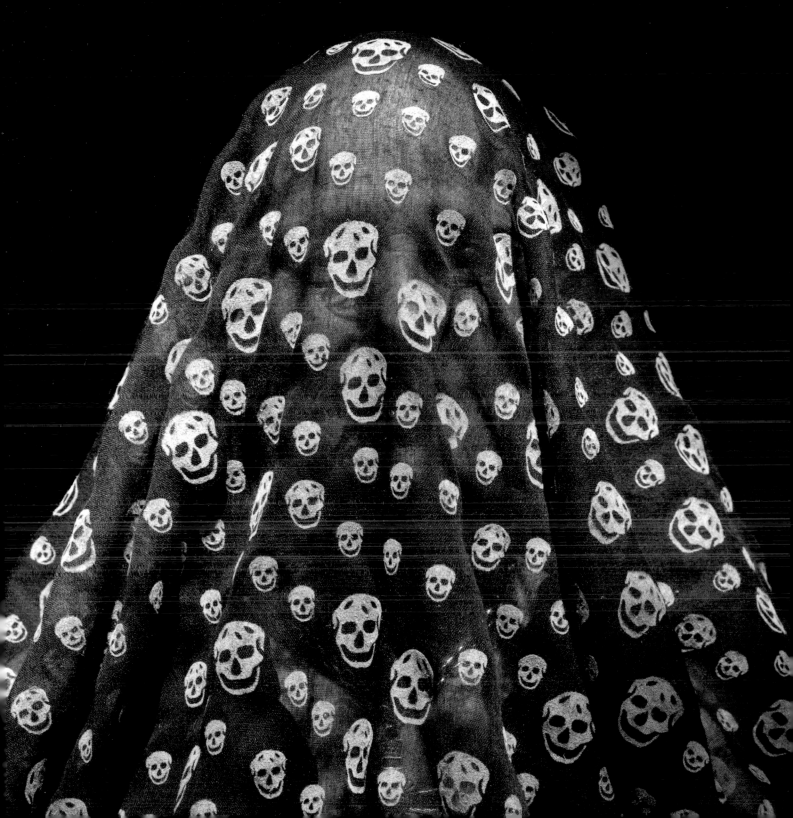

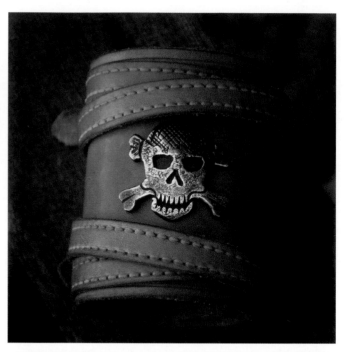

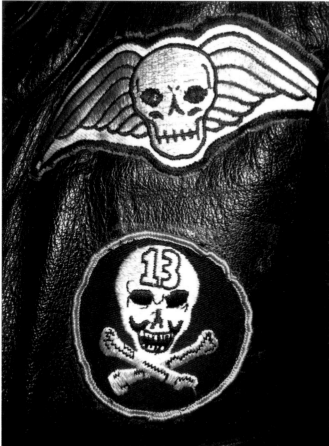

Skulls embellish a couple of leather jackets, a wrap bracelet, and a T-shirt.

Facing: Double Indian head skulls embroidered on a denim jacket.

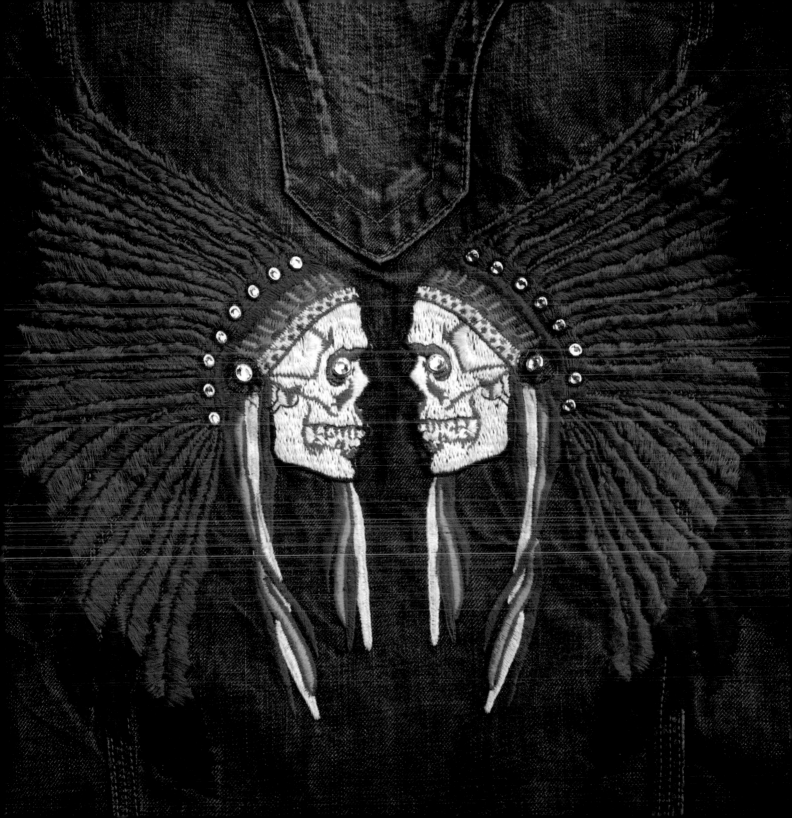

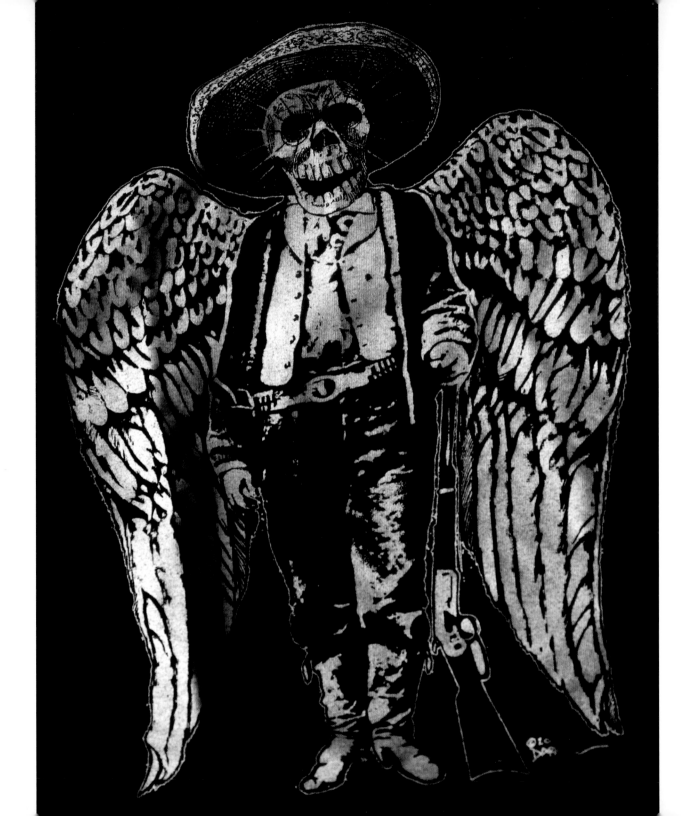

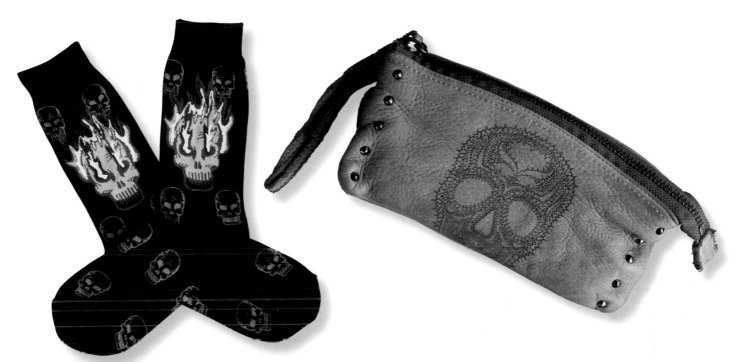

Facing: An original design on a shirt features a winged skeleton figure.

This page: Flaming skull socks; a Zadig & Voltaire turquoise wallet; boxer shorts.

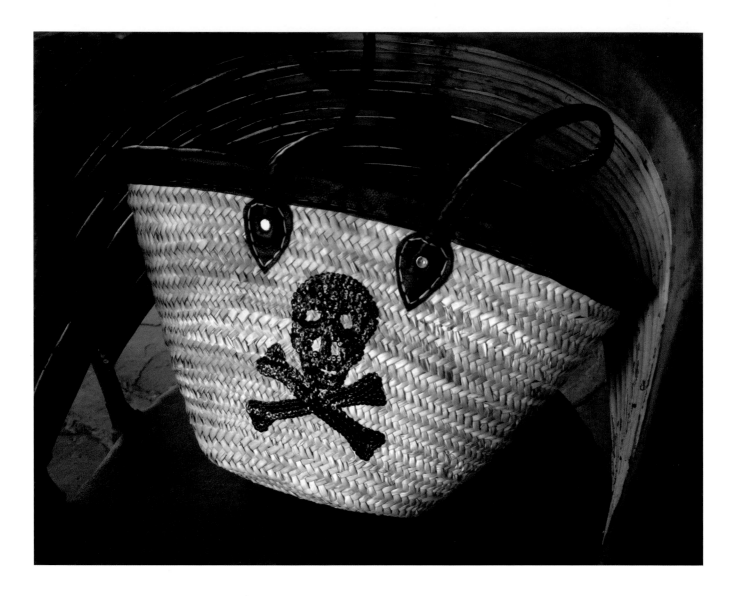

A Moroccan straw basket with black sequined
skull and a fun umbrella. There isn't a corner of
consumerism that hasn't been infected with skulls.

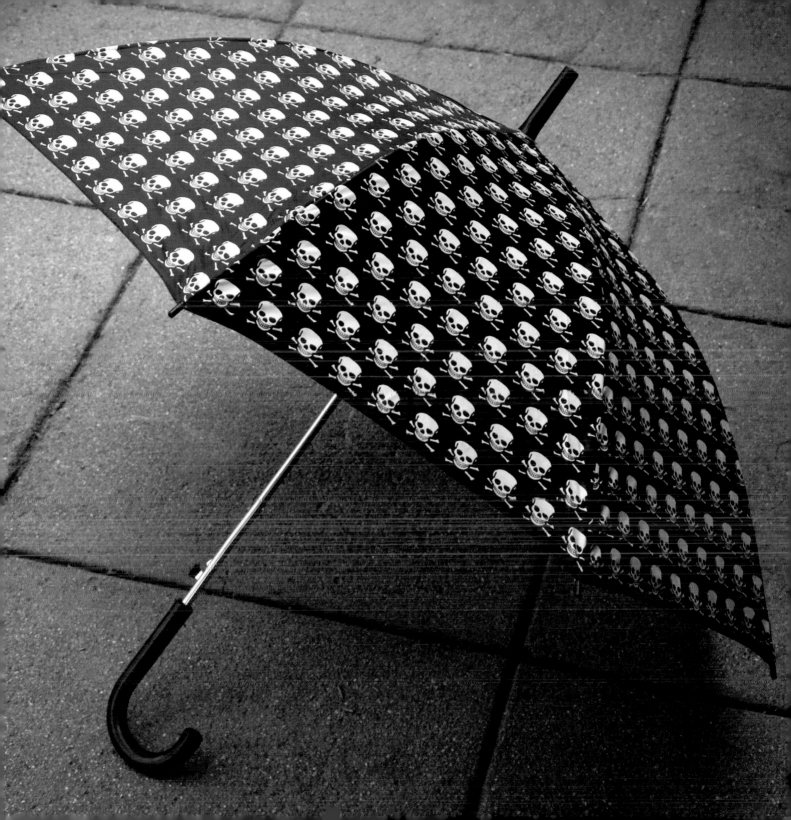

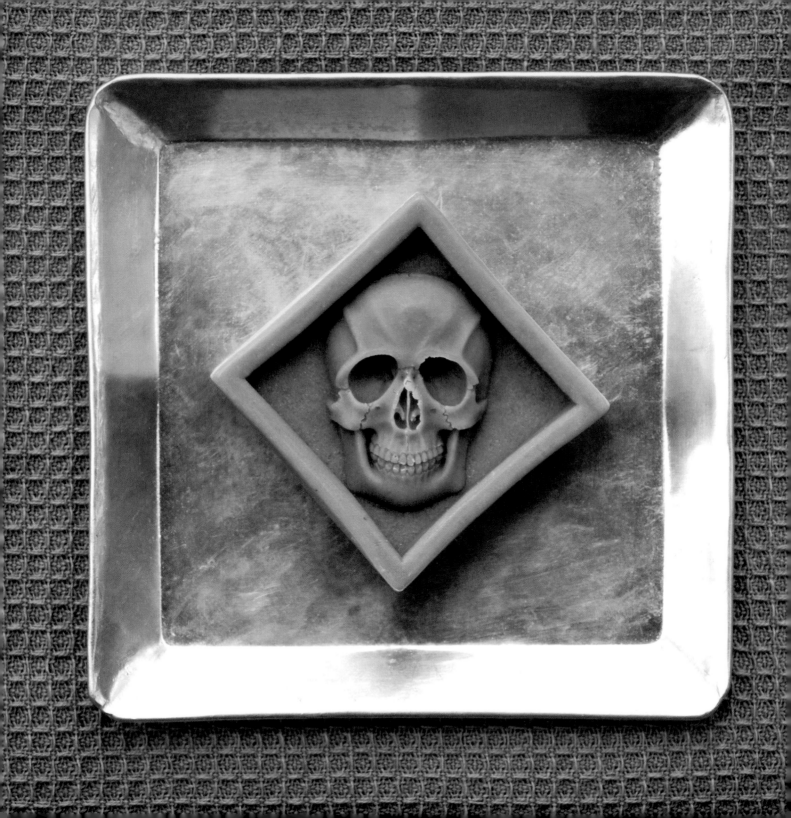

TCHOTCHKES

✱

It's a Yiddish word with several meanings; I only know one—sheer fun. An inexpensive gift; a showy trinket. Boy, have I had a million of them, all fun and grin provoking. Who hasn't had a coffee mug with a pig or cat on the side? Even a shelf full of shot glasses from obscure bars across the West. My personal favorites were belts with the states on the back; some were silver studded, had reflectors, beads, or hand-painted leather cutouts. I met a million people with those belts. A friend of many years went for frogs; once discussed with her friends the gifts started pouring in. At the last check, the opening front door said ribbit!

Just mention to your friends that you're collecting skulls and watch what happens . . .

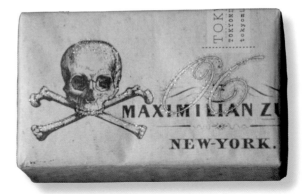

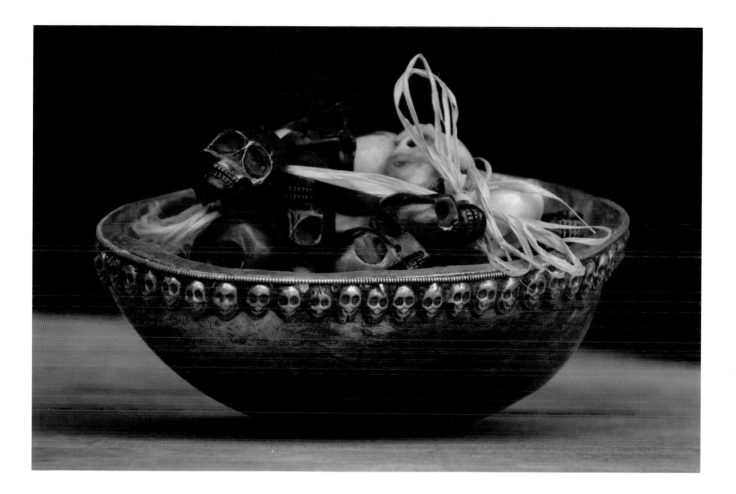

Facing: A tote bag; an unusual piece of folk art (top right); a classy skull and crossbones package for a bar of soap from Maximilian New York.

This page: A fabulous burl bowl is embellished with a rim of small silver skulls.

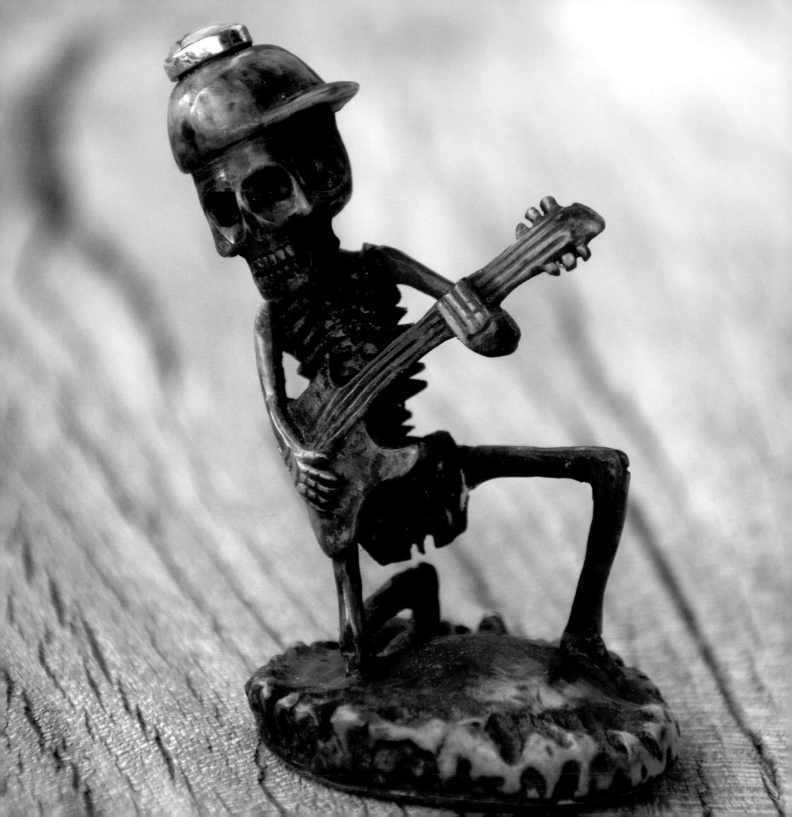

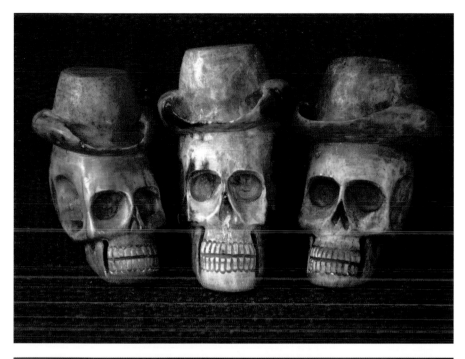

Intricately carved antler and bone skeletons and skulls display the humor that skull collectors are dying to discover.

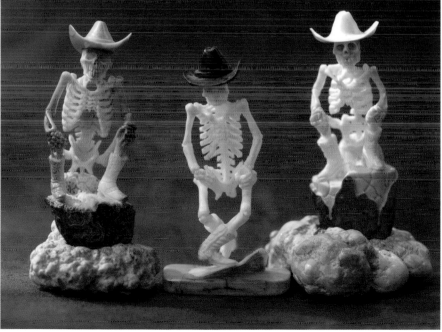

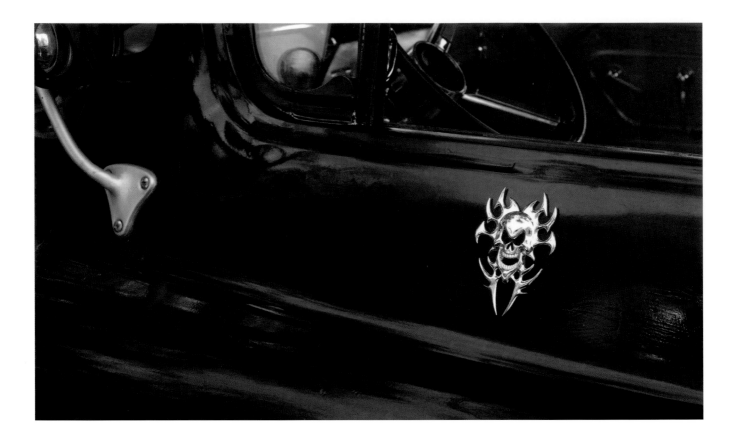

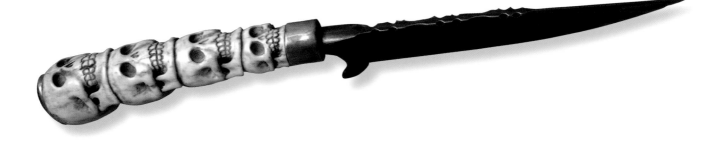

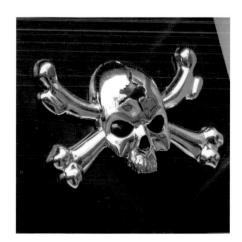

Skulls for the tough crowd: chrome insignias; a decal for the truck; and an expertly crafted knife with carved bone handle.

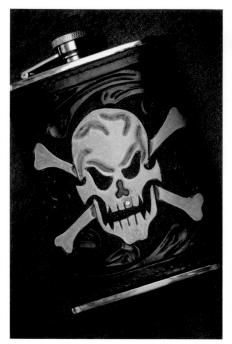

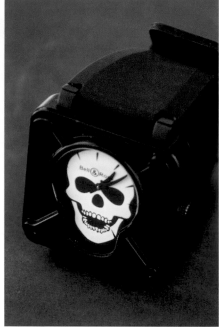

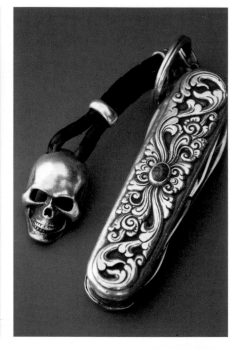

A tooled leather flask cover;
a Bell and Ross rubber watch
with band; a bauble hanging
from a pocketknife; a skull
carved from stone.

Facing: A skeleton as elegant
as a ballerina, carved from
antler.

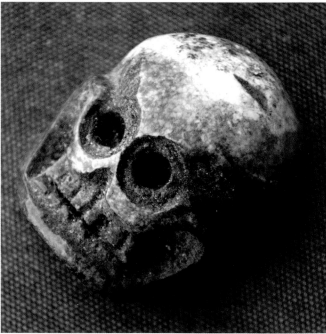

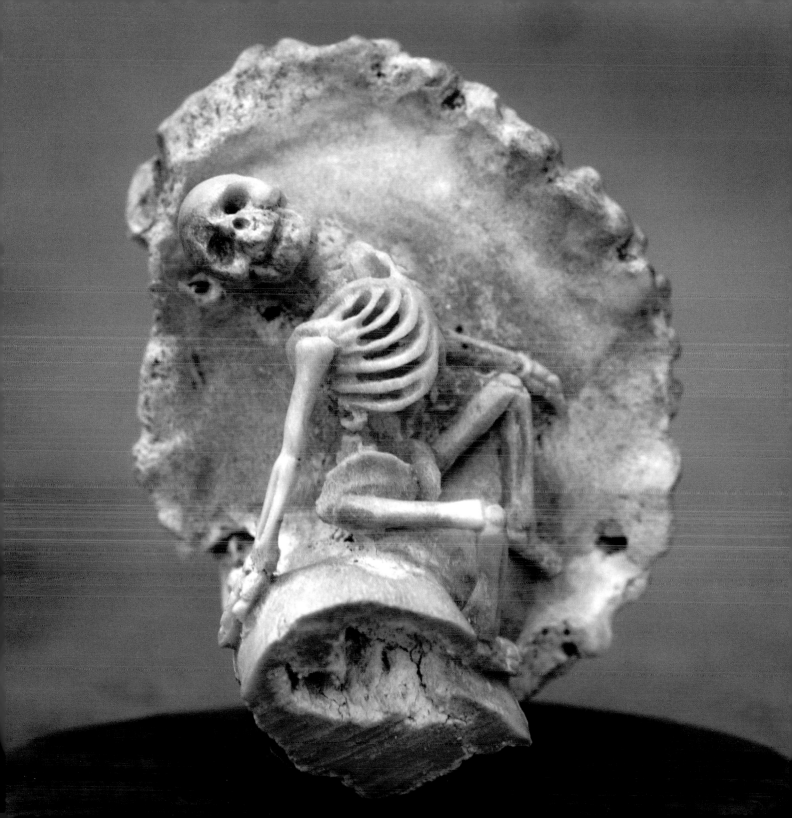

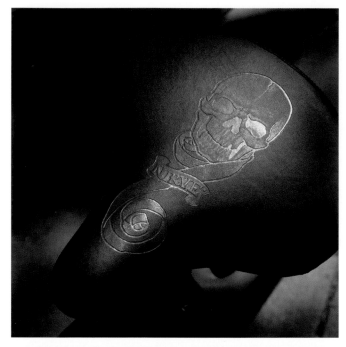

Skull accouterments for people with wheels: a leather bicycle seat; a valve stem cap; a door lock pull.

Facing: A Nirve bicycle with a skull design created by a tattoo artist!

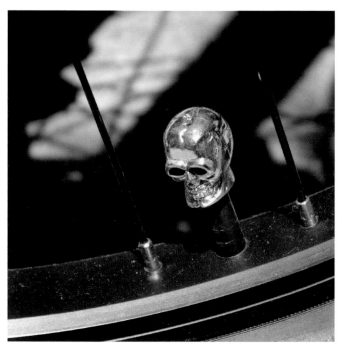

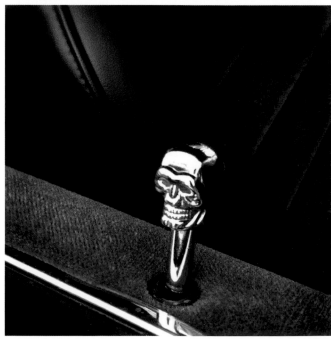

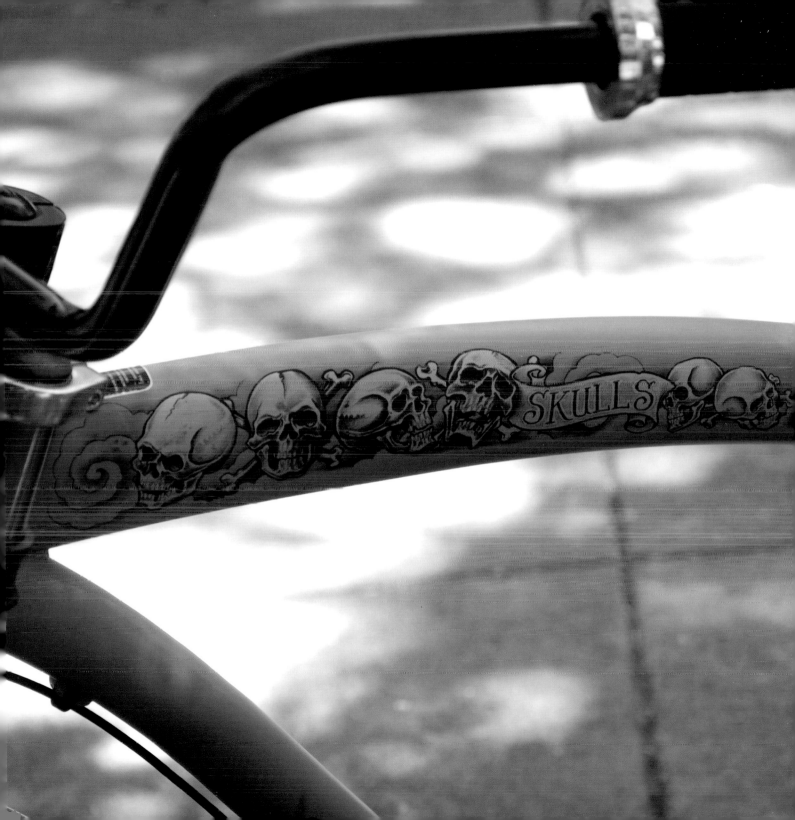

Packard's on the Plaza
61 Old Santa Fe Trail
Santa Fe, NM 87501
505.983.9241
800.648.7358
shoppackards.com
Artists: Dian Malouf, Doug
 Magnus, Lawrence Baca

Que Tenga Buena Mano
P.O. Box 762
Santa Fe, NM 87504
505.983.2358
collectorsguide.com/buenamano
By appointment

The Rainbow Man
107 E. Palace Ave.
Santa Fe, NM 87501
505.982.8706
rainbowman.com

Recollections
1225 Cerrillos Rd.
Santa Fe, NM 87505
505.988.4775
recollectionssantafe.com

Rio Bravo Trading Co.
411 S. Guadalupe St.
Santa Fe, NM 87501
505.982.0230
riobravosf@aol.com

Rippel and Company
111 Old Santa Fe Trail, 2nd Floor
Santa Fe, NM 87501
505.986.9115
rippelandco@gmail.com
johnrippel.com

Shiprock Santa Fe
53 Old Santa Fe Trail, 2nd Floor
Santa Fe, NM 87501
505.982.8478
shiprocksantafe.com

Stephen's
2701 Cerrillos Rd.
Santa Fe, NM 87507
505.471.0802
stephensconsignments@zianet.com

Todos Santos Chocolates
125 E. Palace Ave. #31
Santa Fe, NM 87501
505.982.3855

Traveler's Market
153B Paseo de Peralta
Santa Fe, NM 87501
505.989.7667
travelersmarket.net

Wahoo! Santa Fe
227 Don Gaspar Ave.
Santa Fe, NM 87501
505.577.8200
wahoosantafe.com

The Whole Package
518 Old Santa Fe Trail #1
Santa Fe, NM 87505
505.986.8885
info@twpgifts.com
twpgifts.com

NEW YORK

Amedeo
958 Lexington Ave.
New York, NY 10021
212.737.4100
amedeonyc.com

Barbara Trujillo Antiques
2466 Main St.
Bridgehampton, NY 11932
631.537.3838
Shares space with Kelter-
Malcé and Ramaekers.

Bead USA
1006 6th Ave.
New York, NY 10018
212.278.8133

Erwin Pearl
107 E. 42nd St.
New York, NY 10017
212.922.1106
erwinpearl.com

The Evolution Store
120 Spring St.
New York, NY 10012
212.343.1114
info@theevolutionstore.com
theevolutionstore.com

Meae Bang
1000 6th Ave.
New York, NY 10018
212.302.0377
meaebang.com

Melet Mercantile
84 Wooster St. #205
New York, NY 10012
212.925.8353
desk@meletmercantile.com

Necessary Clothing
676 Broadway
New York, NY 10012
646.214.7881
necessaryclothing.com

Pan American Phoenix
857 Lexington Ave.
New York, NY 10065
212.570.0300
panamphoenix.com

Ralph Lauren
109 Prince St.
New York, NY 10012
212.625.1660
poloralphlauren.com
Ayers candle.

Rugby by Ralph Lauren
32 Main St.
East Hampton, NY 11937
631.907.0960

Zadig & Voltaire
409 Bleecker St.
New York, NY 10014
212.414.8470
zadig-et-voltaire.com

TEXAS

Richard Schmidt Jewelry Design
118 N. Washington St.
La Grange, TX 78945
979.968.5149
800.368.9965

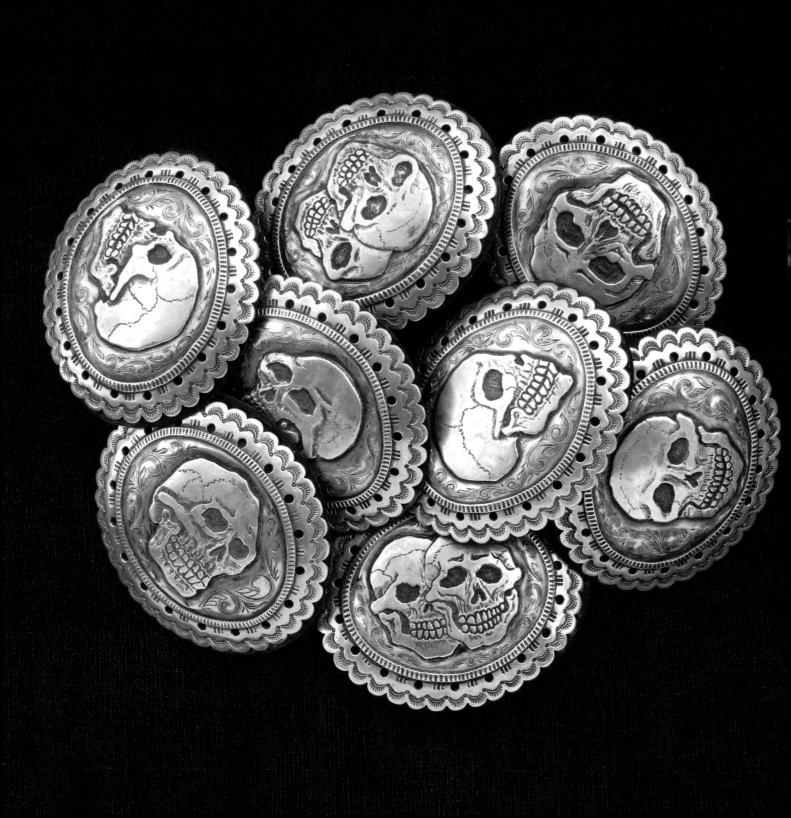